D0897343

9

BLACK AMERICA SERIES

WASHINGTON, D.C.
1963–2006

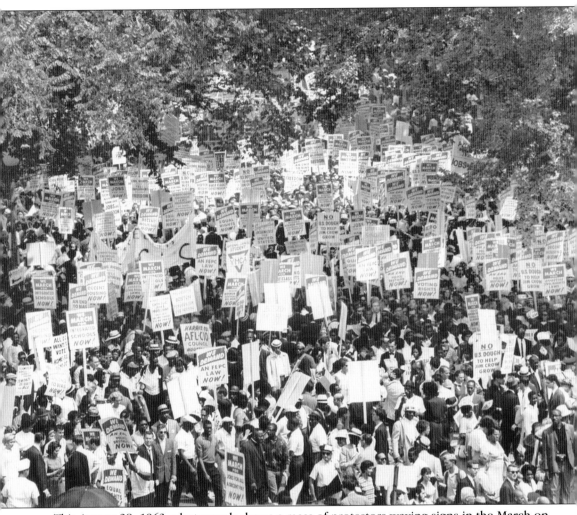

This August 28, 1963, photograph shows a mass of protestors waving signs in the March on Washington for Jobs and Freedom. The signs carry slogans from "We March for Integrated Schools Now" to "We Demand Voting Rights Now." (Courtesy National Archives, August 28, 1963.)

ON THE FRONT COVER: Seen in this photograph are participants in the 1963 March on Washington. (Courtesy National Archives.)

ON THE BACK COVER: Photographer Addison Scurlock's work most often chronicled the lives of affluent and influential African Americans in Washington, D.C. Pictured here on their 50th wedding anniversary (November, 1962) are Addison and Mamie Scurlock, their sons, and their families. (Scurlock Studios, courtesy Smithsonian Institution.)

BLACK AMERICA SERIES

WASHINGTON, D.C.
1963–2006

M _____ Date 3/28/09

Address _____

Reg. No. _____

	Clerk	Account Forward		
1	DC - 1963-06			
2				
3			9	oc
4				
5			52	
6				
7			9	52
8				
9				
10				
11				
12				
13				
14				
15				

CAPITOL HILL BOOKS
657 C Sreet, SE
Washington, DC 20003
(202) 544-1621

57003-25

35 Your Account Stated to Date - If Error is Found, Return at Once

tt
Baker

Copyright © 2007 by Tracey Gold Bennett
ISBN 978-0-7385-4383-3

Published by Arcadia Publishing
Charleston SC, Chicago IL, Portsmouth NH, San Francisco CA

Printed in the United States of America

Library of Congress Catalog Card Number: 2006933628

For all general information contact Arcadia Publishing at:
Telephone 843-853-2070
Fax 843-853-0044
E-mail sales@arcadiapublishing.com
For customer service and orders:
Toll-Free 1-888-313-2665

Visit us on the Internet at www.arcadiapublishing.com

*I dedicate this book to my mother, Dianne Williams Bennett,
my grandparents Mildred and James Williams,
uncles James Mitchell and Ronald Williams,
and Aunt Rosalyn Edwards,
in memory of my father, Alan Douglass Bennett,
and cousin Reginald Edwards,
and to the city of Washington, D.C.*

CONTENTS

ACKNOWLEDGMENTS

First, I thank God for his guidance and protection and for sending such wonderful people in my life to make this happen. This book, the second in the Black America series about Washington, D.C., was truly a collaborative, community effort. I absolutely could not have completed this book without the help of celebrity photographer and native Washingtonian Ron Baker. Mr. Baker is without a doubt one of the most accomplished, gifted, talented, and humble individuals I have ever met. It was his commitment to the African American community that compelled him to participate in this project, and for that I will always be grateful. Second, one of the lessons I learned while researching this material is that family comes first. Not work, not achievements, not when it's convenient, but always, because if by chance we were to lose everything today or tomorrow, our family would be there to support us. Next, the list is long so bear with me; thank you to the following people: Ron Williams, Bernard Johnson, and Phyllis Johnson Marvelynn for digging through your family archives for photographs to include in this book; Mildred Williams, my grandmother, for putting up with me calling everyday with updates and for being patient while I learned to operate my Skype internet phone service; James and Cecelia Williams for taking my mind off work with Redskins games, fried chicken, and mashed potatoes; Anna Castro, Robert White, and Yassir Abdalla; I am very grateful to media giant, philanthropist, and community activist Catherine Liggins Hughes, founder of Radio One, and her assistant for helping with Black America: *Washington, D.C.: 1861–1963*; Nizam Ali and the Ali family for the photographs of Ben's Chili Bowl; the Black Civil War Museum; and Candida's Bookstore for supporting me and making me feel at home during my first signings. Thank you Lisa Hobbs and your husband, Dr. Reginald Hobbs, and family for inviting me into your home and assisting with this effort. Thank you, Arcadia Publishing, Lauren Bobier, Courtney Hutton, Jacqueline Pelzer, and Kathryn Korfonta for this opportunity. Finally, I am thankful for the support of my family, my mentors, close friends, and community. "There but for the grace of God go [I]."—John Bradford.

FOREWORD

"Born and raised" in Washington, D.C.—No matter where you venture out into this capital city, that phrase holds a special place in the hearts of those of us who call D.C. our childhood home. As a child, I remembered always seeing a camera around the house and around the neck of Aunt Louise, who co-owned a photography studio somewhere in the city. She could not pass my twin brother Donald (a nationally known photographer) and me without taking a picture. She passed October 4, 2006, at the age of 87, but she had established a tradition of documenting the times of our lives.

When I was 13 years old, I asked my mother (Bernice) to please give me two and a half books of those Top Value trading stamps so I could run to the Peoples Drug Store across the D.C./Maryland line and get one of those instamatic cameras. Why she said yes only God knows because she worked hard to fill up those books with yellow stamps with the Top Value logo on each stamp, books of stamps that you could only accumulate by making purchases from a Peoples Drug Store. Well, I took those two and a half books of stamps she gave me and tore a path to that Peoples Drug Store and purchased that Anscomatic plastic camera. The Kodak Insta-matic required more stamps, and I was not about to press my luck asking my mother for more of her precious books of stamps.

I imagined myself a *Life* or *Jet* magazine photographer. I remember taking photographs of my neighborhood friends and the activities they were engaged in. I felt the sense of importance my playmates had when my camera was pointed in their direction and how that feeling filled my soul when my friends reacted to the pictures when I returned from picking then up from the Peoples Drug Store down the hill. That camera gave me a sense of self worth that remains with me to this day. Those early photographs gave way to pictures of my friends growing up and moving away and moving on with their lives and of the heroes of the neighborhood like Mr. Jack, who owned the neighborhood barbershop; photographs of the boys who sang on the corner and turned that gift into their first album, which featured photographs they commissioned me to take; photographs that forever keep me connected to my childhood and the purpose God gave to me through my mother's gift of two and a half books of Top Value trading stamps.

I don't know how the gift was given to those whose photographs fill this book documenting a portion of the history of Washington, D.C., but each found their purpose and used that gift one time or for a lifetime so that others might know what they knew and see what they saw in the most powerful city in the world. More importantly, the young author of this compilation has used her gifts from God to archive and protect the history of this city the best way she knows how . . . through words, photographs, and a burning spirit to share with others.

—Ronald G. Baker

INTRODUCTION

When you take a look at the first photograph in *Washington, D.C.: 1963–2006*, study the faces. They are the faces to whom we owe a debt of gratitude. These people endured unimaginable assaults to their dignity for one reason—because they were African American. Those who demonstrated in the 1963 March on Washington were news-makers and regular people, mothers, fathers, men and women, middle and working class, white and blue collar, African American, and otherwise.

Likewise, in *Washington, D.C.: 1963–2006* are photographs of people who represent a wide swath of African American experience in D.C. from the elite to celebrity personalities (who visited and entertained the masses) to the everyday family.

Washington, D.C., is a bastion of opportunity for African Americans; still, there are challenges. Included in this book are photographs of a typical extended family (Johnson and Williams families) with deep roots in the South, who like many other Washingtonians migrated to the city because more opportunities existed here than elsewhere.

Bernard Caroll Johnson, former deputy chief of the Washington, D.C., Fire Department, described what it was like coming of age and then raising a family in a city with limitations: "Back then you had no options you could be a firefighter, teacher, police officer or nurse," he said.

However, despite the advances the city offered, there was a time when African Americans could not move about freely in the nation's capital. Jim Crow laws supported a system of segregation and discrimination, and blacks did not have the same opportunities as their white cohorts. African American children were educated in separate and inferior schools, families lived in segregated neighborhoods, and even Saturday afternoon lunch and shopping trips were marred by the barriers of race. African Americans could not eat or shop in certain establishments even if they could afford to do so.

Johnson grew up on Rhode Island Avenue, in the Northeast section of the city, and was one of a small group of boys to integrate John Caroll Catholic High School. "Some of us made it others didn't and dropped out," he noted.

What is remarkable about this story is that despite the limitations imposed on African Americans, the community still persevered in hopes that one day things would change.

"Segregation just killed black people, some blacks thought it was painful, but I knew a new day was upon us," said Johnson.

We begin with photos of the 1963 March on Washington because Dr. Martin Luther King and the brave individuals who participated in the civil rights movement were the catalysts for change. *Washington, D.C.: 1963–2006* picks up where *Washington, D.C.: 1861–1962* left off. This photographic history book chronicles the nexus of the civil rights movement, which gave way to a cultural, social and political renaissance that embodies a "New Day" of endless opportunities for African Americans in one of the most powerful cities in the nation—if not the world.

One

CIVIL RIGHTS AND EVENTS ETCHED IN OUR SUBCONSCIOUS

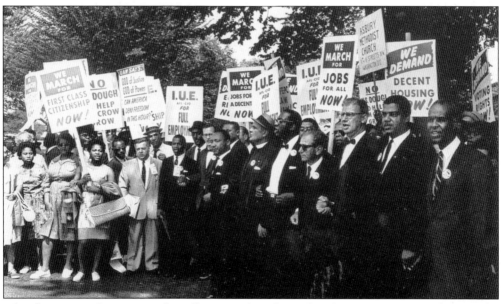

What force caused a quarter of a million people to leave their homes one August day in 1963, put their jobs and responsibilities on hold, and venture to the nation's capital to participate in a civil rights march? Dr. Martin Luther King Jr. was that powerful force behind the movement that compelled the masses. On that day, August 18, 1963, the March on Washington became the catalyst for changing institutional racism and discriminatory practices in the United States. Here Dr. King is shown in the center of a group of demonstrators holding signs demanding decent housing, jobs, and first-class citizenship for African Americans, and proclaiming "No Dough for Jim Crow." (Courtesy National Archives.)

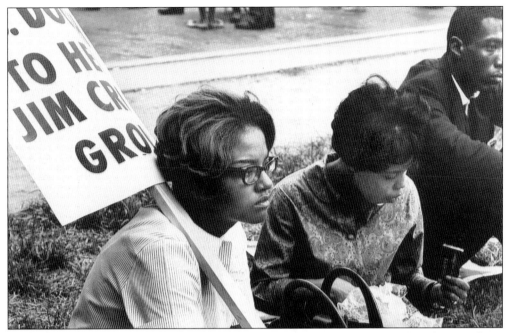

This photograph shows two unidentified young women who participated in the March on Washington. On that day, these women most likely heard speeches by Student Nonviolent Coordinating Committee (SNCC) organizer John Lewis, now Congressman John Lewis (D-Georgia), and labor organizer A. Phillip Randolph, who had tried unsuccessfully years earlier to organize a similar march. (Courtesy National Archives.)

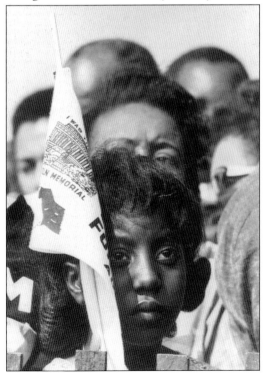

The March on Washington would resonate powerfully around the world for decades to come, but in some parts of the United States, the hatred and violence against African Americans continued. The Pulitzer Prize–winning documentary *Eyes on the Prize* chronicles the civil rights movement and includes footage from the remains of the Sixteenth Street Baptist Church in Birmingham, Alabama, after it was bombed. Four young African American girls were killed in the bombing, which happened only a few weeks after the young woman in this photograph witnessed Dr. Martin Luther King delivering his historic and inspiring "I Have a Dream" speech. (Courtesy National Archives.)

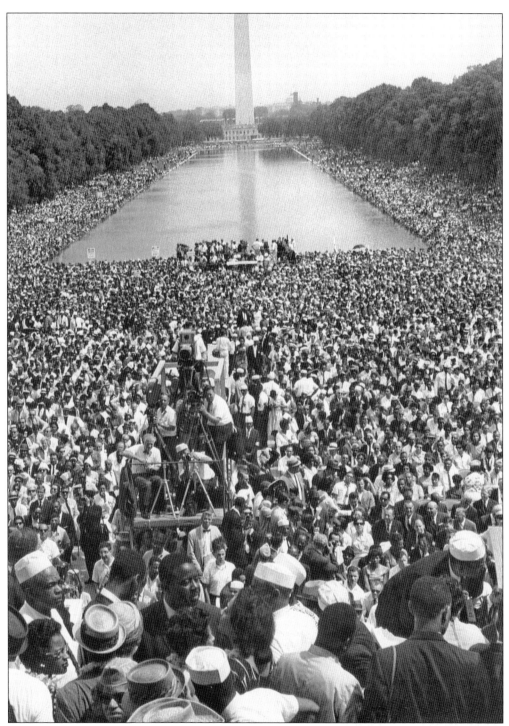

The majority of the crowd seen in this photograph were African American; however, other races and ethnicities also participated in the 1963 March on Washington. Peaceful and nonviolent, the marchers listened intently to Dr. King as he spoke of a world where people would be judged by character, not on the basis of their race. (Courtesy National Archives.)

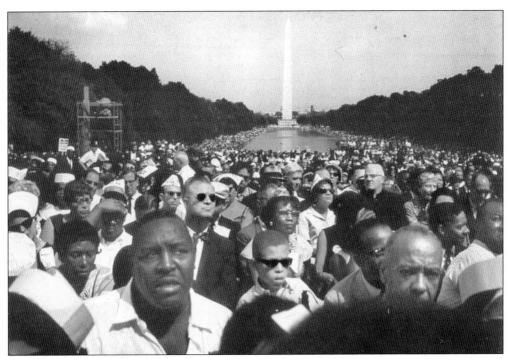

The Lincoln Memorial was the site of the event, but participants could be seen on the National Mall grounds in this photograph as far as the Washington Monument. A camera crew films the event. (Courtesy National Archives.)

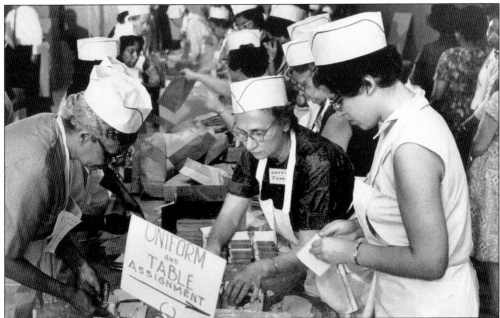

This photograph shows volunteers preparing food for the event. During that period, there were certain restaurants where African Americans were not allowed to dine. According to one Washington resident, if they chose to sit down at one of these restaurants, they simply wouldn't be served. (Courtesy National Archives.)

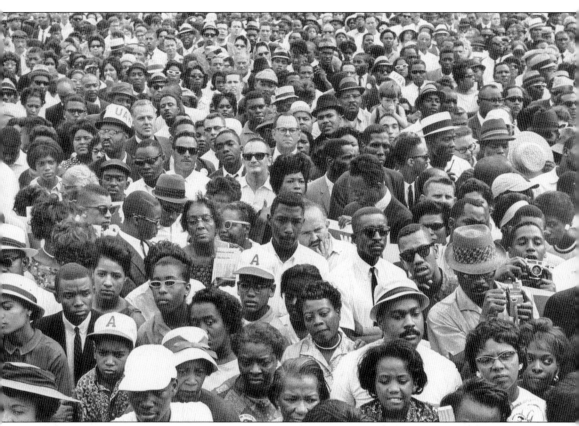

Because of the determination of Dr. Martin Luther King and other civil rights leaders, the men and women in this photograph, and countless more who banded together and made their voices heard in the March on Washington For Jobs and Freedom, the 1964 Civil Rights Bill was passed. (Courtesy National Archives.)

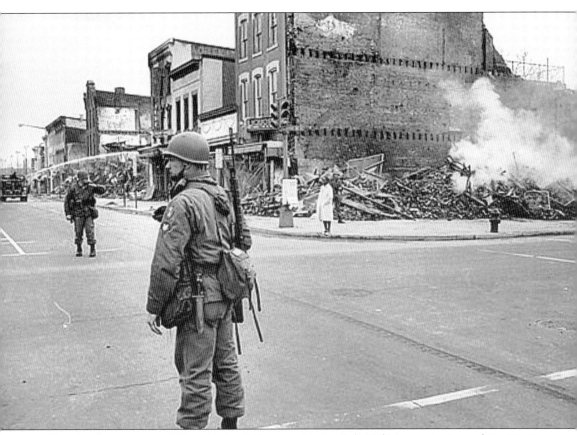

Riots broke out around the country following the April 4, 1968, assassination of Dr. Martin Luther King Jr. This photograph shows the National Guard patrolling the streets in Washington as plumes of smoke rise from buildings in the background. (Courtesy Addison Scurlock Collection, Smithsonian Institution.)

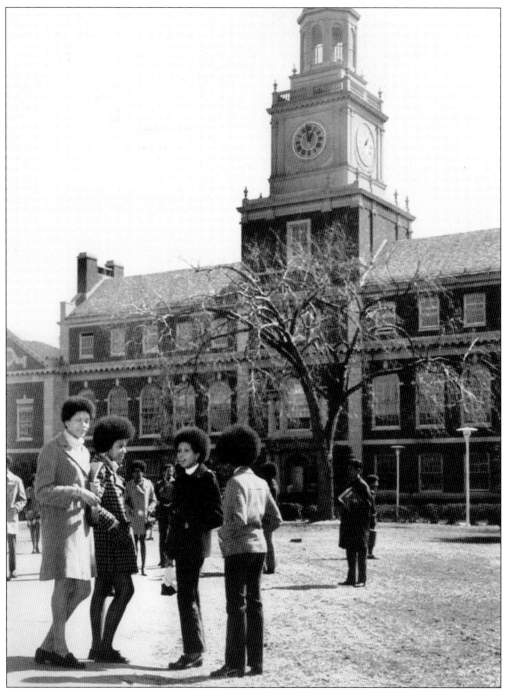

The 1970s were a time of transition. The turmoil of the 1960s had given birth to the "black power" movement. This photograph depicts four female students with Afro-style haircuts in front of Founders Library on the campus of Howard University. That same year in August, publisher Earl Graves's *Black Enterprise Magazine* debuted. *Black Enterprise* is a magazine focusing on business, financial, and consumer issues. (Scurlock Studios, courtesy of the Smithsonian Institution.)

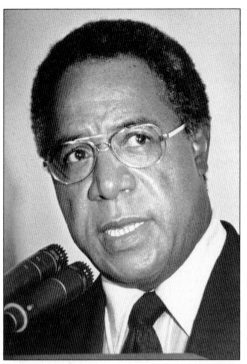

Alex Haley speaks to the audience at a packed Congressional Black Caucus Dinner in 1978 in Washington, D.C. At that time, Haley was touring the world as a result of the success of his book *Roots* and the landmark television mini-series it inspired. (Courtesy Ron Baker.)

In this photograph, Alex Haley autographs his book *Roots* for a dedicated fan in 1978 at a book-signing event held in Washington, D.C. (Courtesy Ron Baker.)

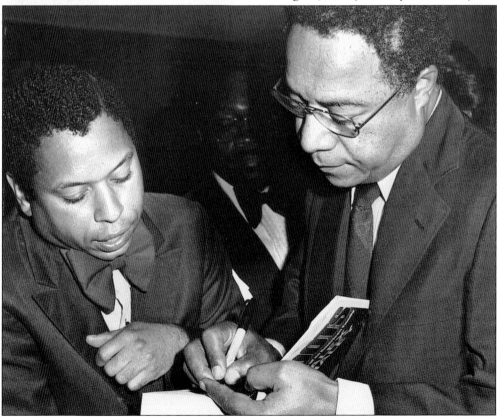

American hostages received a warm welcome as they entered the White House grounds in 1981. The group was held for 444 days in Tehran inside the U.S. Embassy. Pres. Ronald Reagan's Inaugural Day—January 20, 1981—marked the day of their release. (Courtesy Ron Baker.)

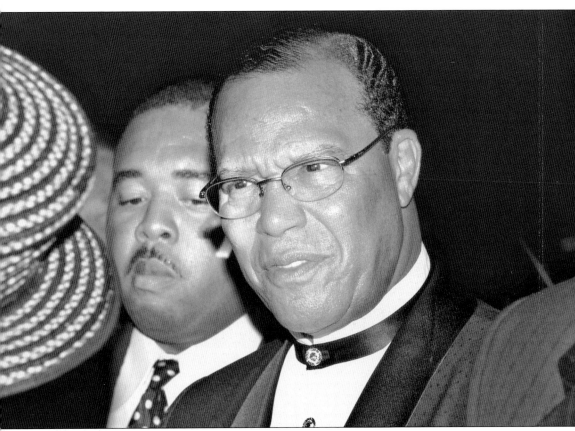

His views on race relations have made Minister Louis Farrakhan one of the most controversial figures of our time. Still his legacy may be organizing the October 16, 1995, Million Man March. Heeding the minister's call, a virtual sea of African American men converged on the National Mall for what Minister Farrakhan touted as "a day of atonement." In this photograph, Minister Farrakhan chats with an attendee at the 2002 Congressional Black Caucus Dinner. (Courtesy Ron Baker.)

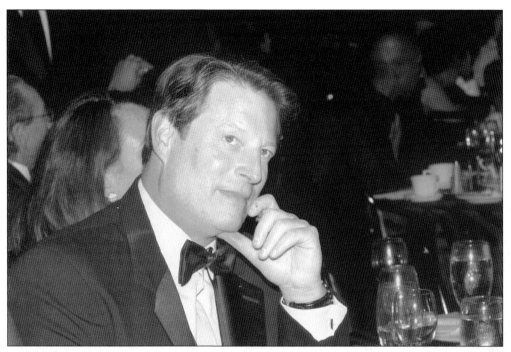

In 2000, Vice Pres. Al Gore attends a Congressional Black Caucus Legislative Weekend at the D.C. Convention Center. (Courtesy Ron Baker.)

Congresswoman Eleanor Holmes Norton is shown here with Vice Pres. Al Gore in 2000. That year, the presidential election between Vice President Gore and George W. Bush would be one of the most hotly contested races in this nation's history. Because the race was so close, a decision hung in the balance as reports spread about voter irregularities and disenfranchisement of minority voters. In December, the Supreme Court ruled that George W. Bush had won the election. (Courtesy Ron Baker.)

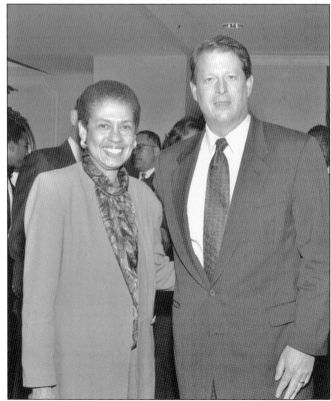

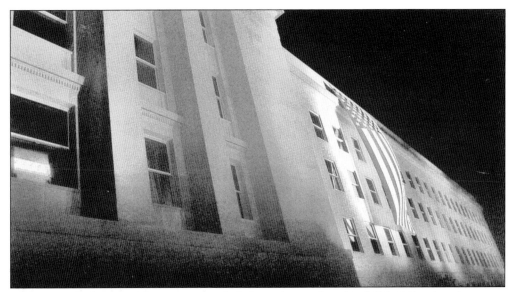

A clear sunny day in Washington turned dark on September 11, 2001, following the worst act of terrorism ever to occur on American soil. Terrorists posing as passengers hijacked four commercial airliners, forced them from their courses, and changed the lives of countless numbers of Americans forever. Two of the aircraft crashed into the World Trade Center Twin Towers, killing nearly 3,000 victims. Forty people died when a third plane went down in Shanksville, Pennsylvania, and another hit the Pentagon; 184 lives were lost there. This photograph shows a flag draped on the Pentagon on September 10, 2006, just one of the ways the 9/11 victims were honored. This display was part of the second annual Freedom Walk. The location of the flag and lights signify the American Airlines Flight 77 point of impact. (Courtesy Department of Defense.)

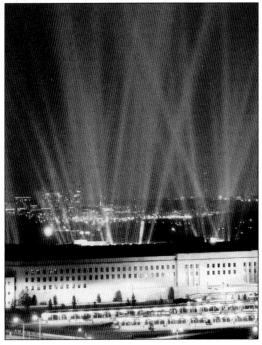

The 184 light beams in this photograph are a symbolic representation of the lives lost in the 9/11 terrorist attack on the Pentagon. (U.S. Air Force photograph/ T.Sgt. Wayne Clark.)

Operations Enduring (Afghanistan) and Iraqi Freedom were the United States' military response to the 9/11 terrorist attacks. Pres. George W. Bush enlisted allies in military response and began a massive global war on terror. On May 25, 2006, Bolling Air Force Base Airman 1st Class Darrell Miller salutes after placing one of 227,000 flags on headstones at Arlington National Cemetery. Miller is a member of the U.S. Air Force Honor Guard Drill Team. Service members from each branch of the military participated in the memorial. (Courtesy U.S. Air Force/ photographer M.Sgt. Jim Varhegyi.)

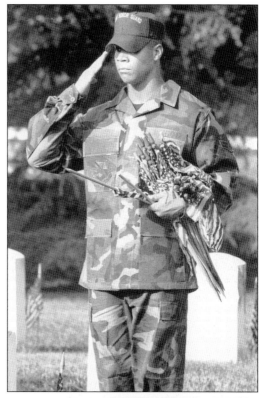

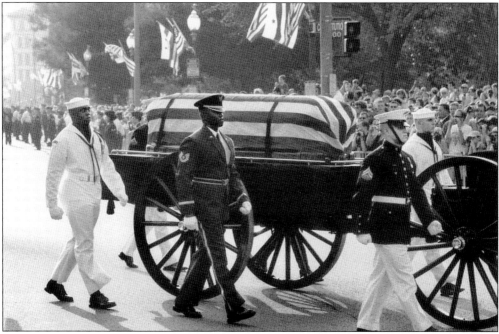

The casket shown in this photograph carries the remains of Pres. Ronald Reagan. A procession led by a military honor guard escorted the president's casket to funeral ceremonies held at the U.S. Capitol. (Courtesy FEMA/photographer Paul Luke.)

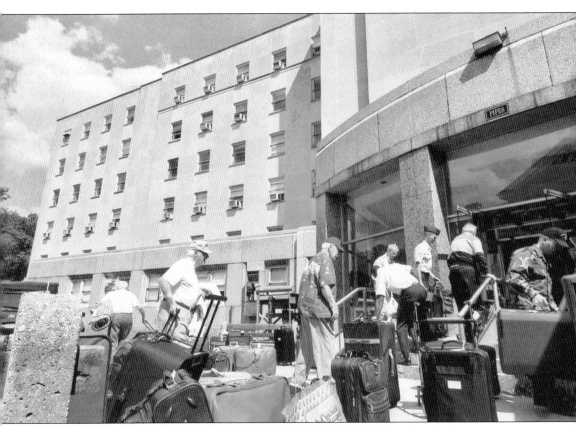

On September 1, 2005, retired service members from Gulfport, Mississippi, arrived in Washington, D.C., after Hurricane Katrina displaced them. Scores of volunteers, civilian and military alike, helped with the move. Here the veterans enter their new residence, the Armed Forces Retirement Home, where they will remain for a year. (U.S. Air Force photograph/S.Sgt. Amber K. Whittington.)

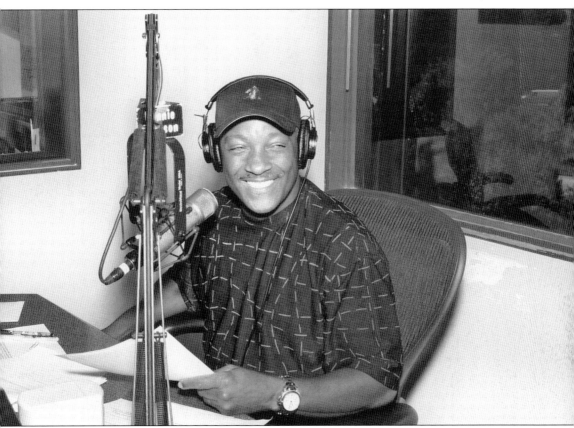

WPGC 95.5 Radio DJ Donnie Simpson spends the entire day on air to solicit donations of money and help for the victims of Hurricane Katrina in 2005. Simpson, known for his generosity in the community, went far and above the call of duty by staying on air after his shift was completed. He motivated thousands to donate food, clothes, and money. (Courtesy Ron Baker.)

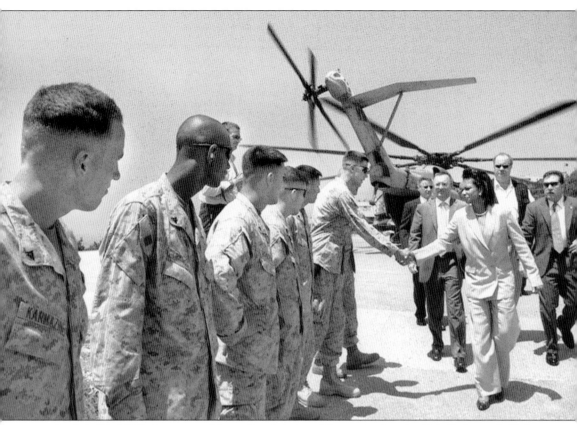

On July 24, 2006, Secretary of State Condoleezza Rice arrived at the U.S. Embassy in Beirut, Lebanon, where she was welcomed by marines. Lebanon and Israel were engaged in a battle following the capture of two Israeli police officers. Secretary Rice flew in from Cyprus. (U.S. Air Force photograph/Senior Airman Brian Ferguson.)

Two

POLITICAL AND SOCIAL
TRAILBLAZERS

Ronald Baker is a photographer in the tradition of Addison Scurlock and Gordon Parks. History serves as a timeline for the events that have created and impacted the African American experience in Washington, D.C. Baker began taking pictures as a child. Over the years, he honed his skills, and the media came calling. Baker's first photograph ever to appear in a commercial publication was a photograph of Miss Black D.C. that appeared in the *Afro* newspaper. Since 1976, he has been taking pictures of celebrities, high-profile news makers, legislators, and heads of state. Many of the photographs featured in this book were taken by Ron Baker. (Courtesy Ron Baker.)

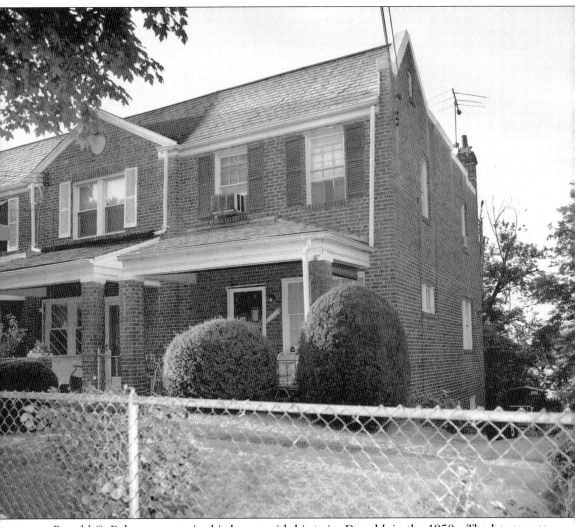

Ronald G. Baker grew up in this house with his twin, Donald, in the 1950s. The house was located on Blaine Street NE in a middle-class neighborhood. (Courtesy Ron Baker.)

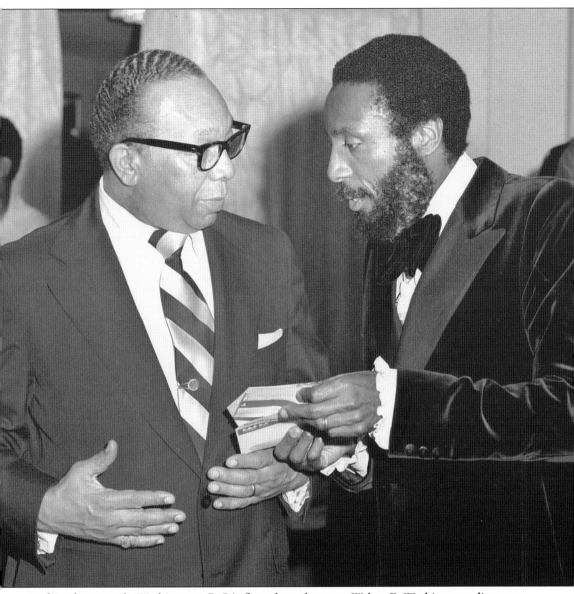

In this photograph, Washington, D.C.'s first elected mayor, Walter E. Washington, discusses issues with comedian/activist Dick Gregory in 1977 during a Congressional Black Caucus Awards Dinner. Washington was appointed mayor/commissioner in 1967, becoming the first African American chief executive of a major U.S. city, and was elected to the post in 1972. Born in 1932 in St. Louis, Missouri, Gregory was hired in 1961 by *Playboy* magazine mogul Hugh Hefner to work at the Chicago Playboy Club after Hefner heard him win an entirely white audience. His 1964 autobiography, *Nigger*, sold more than seven million copies. He became a civil rights activist fighting against the Vietnam War and ran for president in 1968. (Courtesy Ron Baker.)

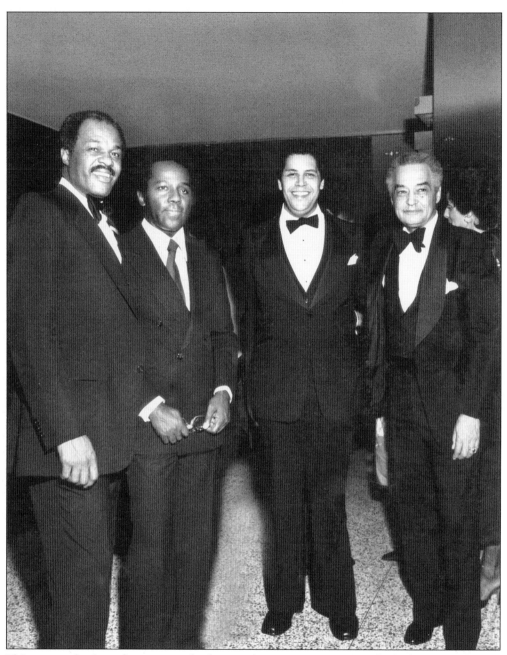

This rare gathering of mayors took place at the 1979 Congressional Black Caucus Awards Dinner in Washington, D.C. From left to right are D.C. mayor Marion Barry; Gary, Indiana, mayor Richard G. Hatcher; Atlanta, Georgia, mayor Maynard Jackson; and Detroit mayor Coleman Alexander Young. Hatcher, the senior mayor in the group, was elected November 7, 1967. Coleman Young was elected in 1973 at the age of 54. Maynard Jackson was elected the first black mayor of Atlanta, winning 59 percent of the runoff vote, on October 16, 1973; and Marion Barry was only the second elected mayor of Washington, D.C., in 1978. (Courtesy Ron Baker.)

Delegate Walter Fauntroy was Washington, D.C.'s first elected representative to Congress and a founding member of the Congressional Black Caucus. Standing with his wife, Dorothy, he was elected in 1971 and served 10 terms in Congress. (Courtesy Ron Baker.)

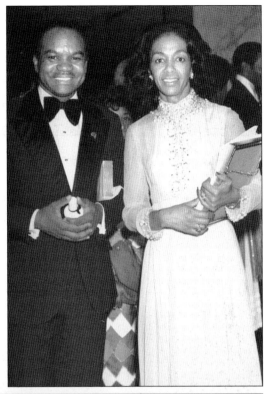

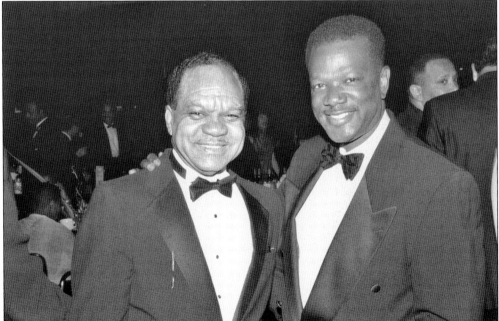

Prince George's County executive Jack Johnson (right) was elected to that office in 2002 after serving as state's attorney for Prince George's County. He was reelected to a final term in November 2006. Standing with former U.S. Congressman Walter E. Fauntroy, Johnson attends the Congressional Black Caucus Awards Dinner. (Courtesy Ron Baker.)

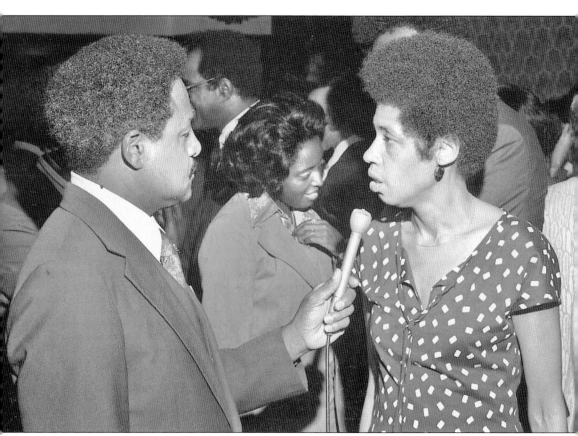

Eleanor Holmes Norton interviews with WUSA-9 television reporter Bob Strickland in 1977. At the time, Norton was chair of the Equal Employment Opportunity Commission, the first woman to be so. She later was elected Washington, D.C.'s first female delegate to the U.S. Congress in 1990, following Congressman Walter E. Fauntroy. (Courtesy Ron Baker.)

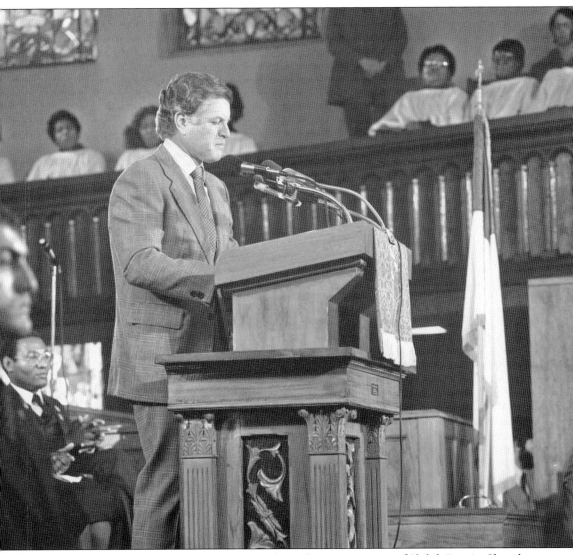

Sen. Edward Kennedy (D-Massachusetts) speaks to the congregation of Shiloh Baptist Church on Ninth Street NW in Washington, D.C., during the 1980 presidential campaign. Kennedy was in a bitter battle with Pres. Jimmy Carter and, when Carter garnered the nomination, refused to shake his hand during the Democratic Convention. Kennedy was reelected to his eighth term as the U.S. senator from Massachusetts in 2006. (Courtesy Ron Baker.)

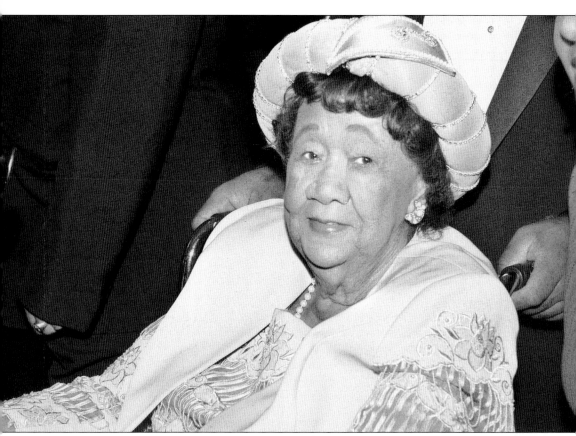

Dr. Dorothy Height is pictured at an event in 2004. Dr. Height took over the leadership reigns of the National Council of Negro Women, succeeding the founder, the late Dr. Mary McLeod Bethune, in 1958. Born in 1912, Dr. Height served on the staff of the YWCA of USA from 1944 to 1977, developing leadership training. Dr. Height inaugurated the Center for Racial Justice. She served as national president of the Delta Sigma Theta Sorority, Inc., from 1946 to 1957 and worked closely with Dr. Martin Luther King Jr., Roy Wilkins, Whitney Young, A. Philip Randolph, and others during the beginning and the height of the civil rights movement. She was given the Citizens Medal Award for distinguished service to the country in 1989 by Pres. Ronald Reagan. (Courtesy Ron Baker.)

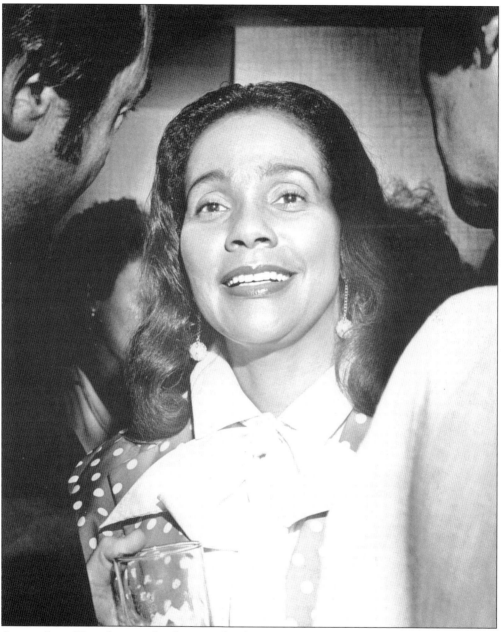

Coretta Scott King glows as she discusses her late husband at a reception held in Washington, D.C., at the Washington Hilton Hotel in 1977. (Courtesy Ron Baker.)

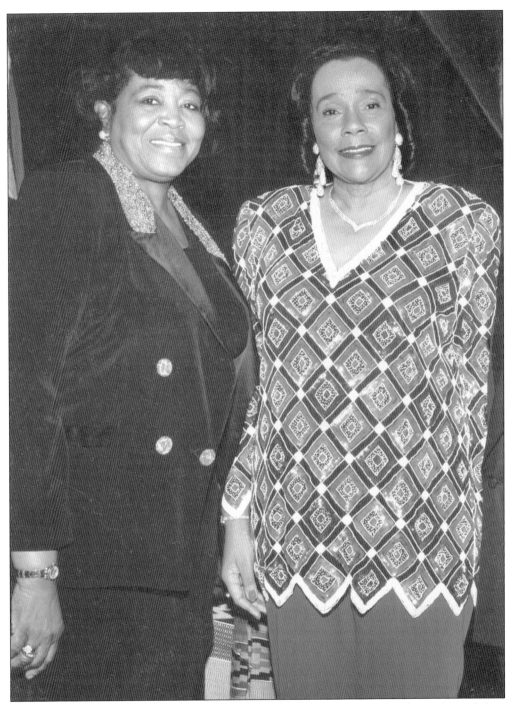

Iconic leaders for civil rights and social justice, Dr. Betty Shabazz (left), the widow of slain Muslim leader Malcolm X, and Coretta Scott King, widow of slain civil rights leader Dr. Martin Luther King Jr., attend a private reception in honor of Nelson Mandela in 1994. Mandela was being honored by Africare. (Courtesy Ron Baker.)

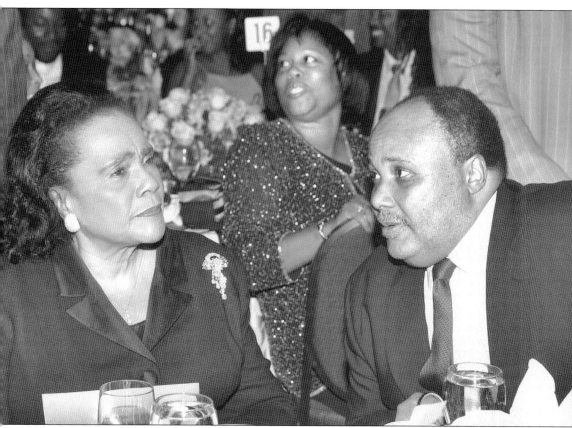

Coretta Scott King, the widow of Rev. Dr. Martin Luther King Jr., talks to her son Martin III at the 2004 Annual Prayer Breakfast hosted by the Congressional Black Caucus. This would be the last time Mrs. King would be able to attend the event because of a stroke she suffered in 2005. Mrs. King passed away January 31, 2006, at the age of 78. Her dedication to Dr. King and her continuation of his work has been the most important factor in maintaining the legacy of Dr. King. (Courtesy Ron Baker.)

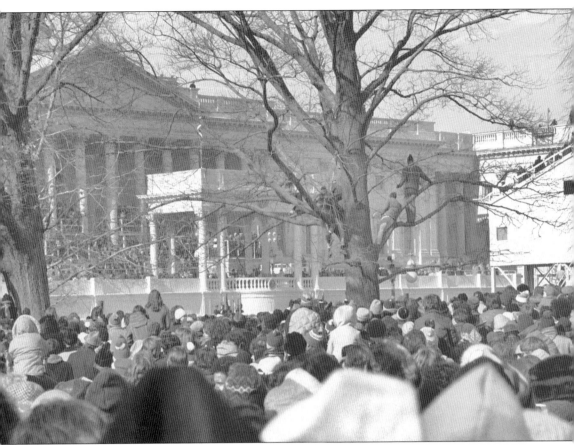

A time-honored tradition allowing the average citizen to participate in the Presidential Inaugural on the grounds of the U.S. Capitol is now a far and distant memory. This photograph was taken during the inauguration of Pres. James Earl Carter on January 20, 1977. Note people lofted in the trees. (Courtesy Ron Baker.)

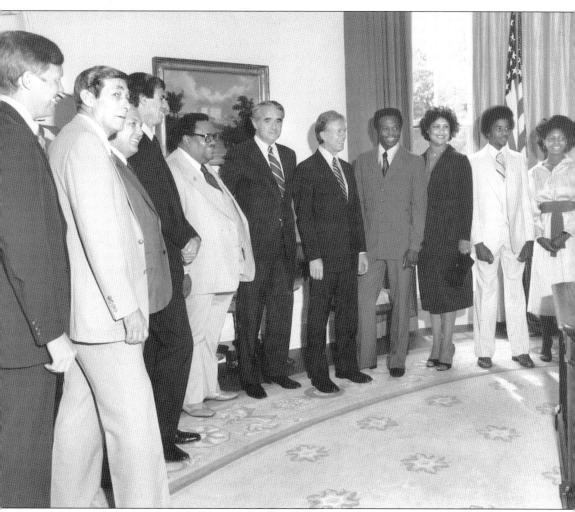

Pres. Jimmy Carter receives St. Louis Cardinal great Lou Brock (fourth from right). Brock, along with his wife and children, presented the president with his bat, glove, and shoes in 1978. (Courtesy Ron Baker.)

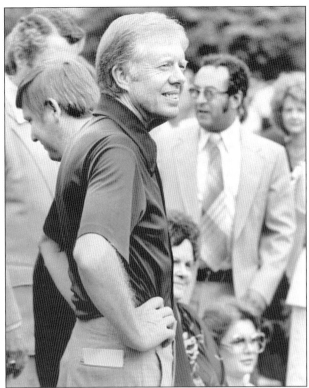

Pres. Jimmy Carter looks relaxed at his celebration of gospel on the White House lawn in 1979. The concert included artists like Shirley Caesar and the Mighty Clouds of Joy. (Courtesy Ron Baker.)

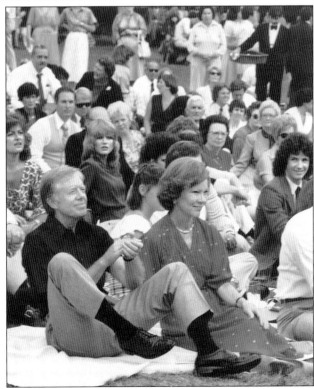

Pres. Jimmy Carter responds to good gospel music along with First Lady Rosalind in 1979. (Courtesy Ron Baker.)

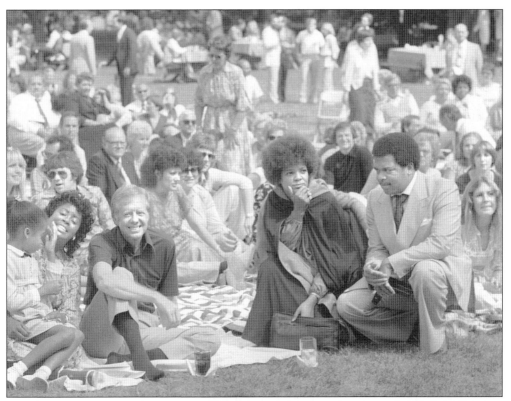

President Carter enjoys the gospel concert he hosted on the White House lawn in 1979. To the right of Carter with the black cape is gospel legend Shirley Caesar. (Courtesy Ron Baker.)

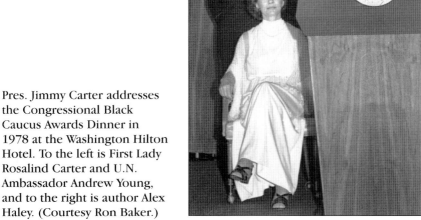

Pres. Jimmy Carter addresses the Congressional Black Caucus Awards Dinner in 1978 at the Washington Hilton Hotel. To the left is First Lady Rosalind Carter and U.N. Ambassador Andrew Young, and to the right is author Alex Haley. (Courtesy Ron Baker.)

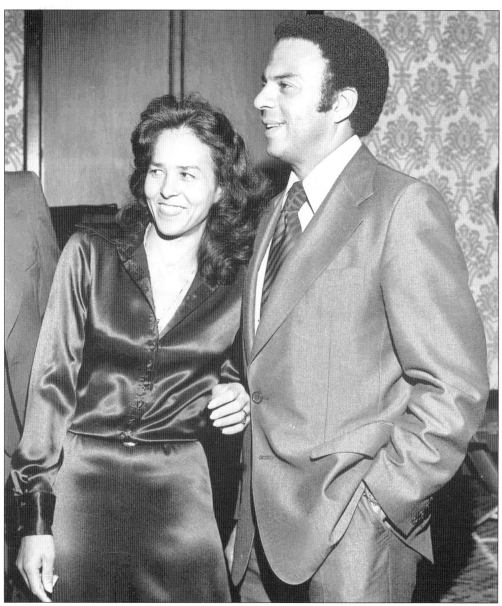

In 1977, U.S. Ambassador to the United Nations Andrew Young and his wife, Jean Childs Young, stopped by to support the Congressional Black Caucus Legislative Week in Washington, D.C., at the Washington Hilton Hotel. Young was appointed by Pres. Jimmy Carter in 1977 and became the first African American to hold that post. He was fired in 1979 by President Carter for supporting talks in the Middle East between Israel and Palestine. He was replaced by Donald McHenry. Young became Georgia's first African American congressman since Reconstruction in 1972 and was reelected for two more terms before accepting the U.N. ambassador post. Young was one of Rev. Martin Luther King Jr.'s lieutenants during the civil rights struggles. In 1981, he was elected mayor of Atlanta, succeeding Mayor Maynard Jackson, and was reelected in 1985. Young was instrumental in bringing the 1996 Olympic Summer Games to Atlanta, though he was not in office when the city was selected by the Olympic Committee. (Courtesy Ron Baker.)

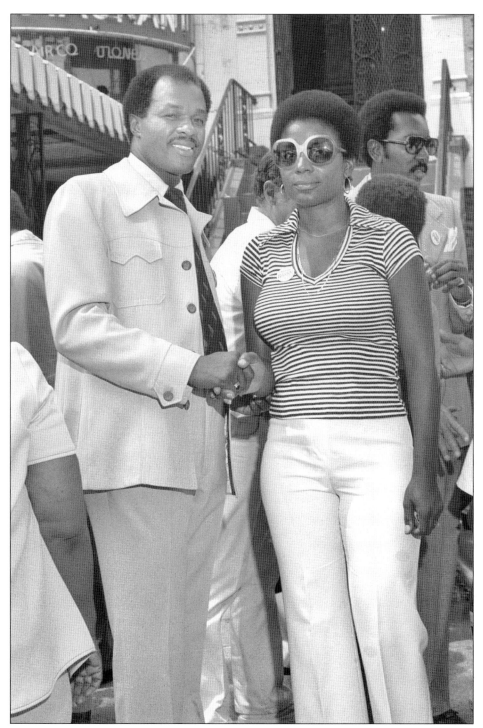

During his campaign for reelection to the D.C. City Council in 1976, Marion Barry poses with Cora Masters outside of Barry's campaign headquarters. At that time, Barry was engaged to Effie Slaughter (they married in 1978), and Masters was heading up the D.C. Boxing Commission. (Courtesy Ron Baker.)

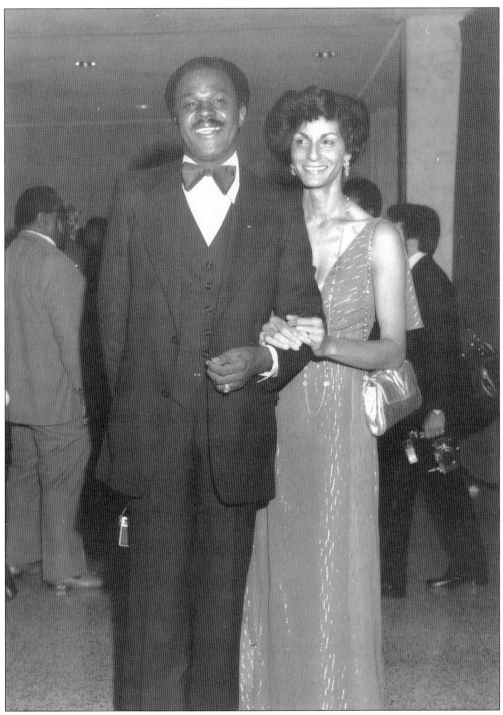

Councilman Marion Barry and Effie Slaughter attend a Congressional Black Caucus gala in 1977. (Courtesy Ron Baker.)

Mayor Barry stands with friend Dewey Hughes (right) *c.* 1979. Hughes was a local television producer with WRC-4 TV in Washington, D.C., in the early 1970s and introduced the late Petey Green to television. (Courtesy Ron Baker.)

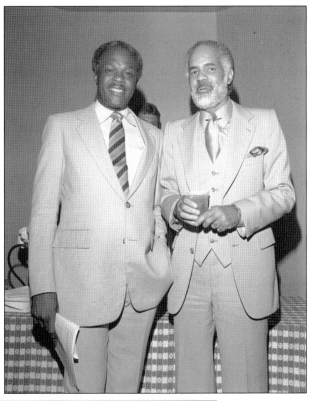

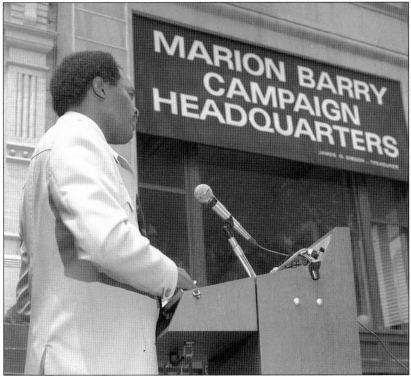

Councilman Marion Barry speaks to supporters during his reelection campaign in 1976. (Courtesy Ron Baker.)

43

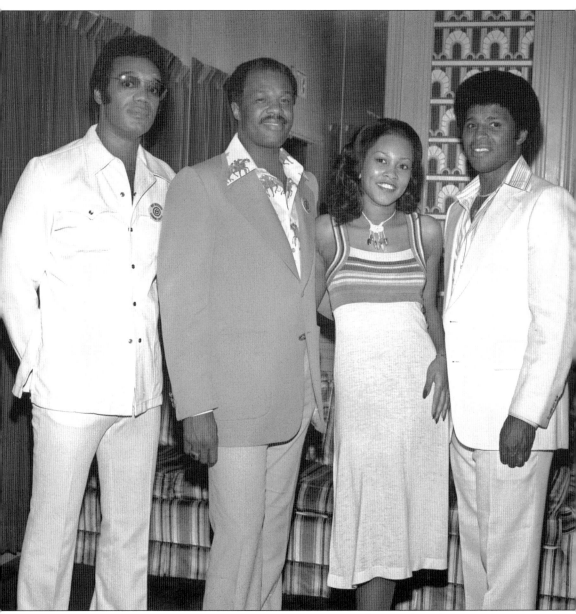

Councilman Marion Barry joins Redskins tight end Roy Jefferson (far left), Miss Black D.C. Avis Harrell, and Redskins safety Brig Owens (far right) at the famed Foxtrappe in Washington, D.C., during a special event in 1977. Roy Jefferson is a successful entrepreneur in Northern Virginia, and Brig Owens began a legal career in the Washington area following his NFL career. Harrell lives in Los Angeles and performs, singing big band hits around the Los Angeles area. (Courtesy Ron Baker.)

Cathy Hughes and Jeff Majors pose at the Congressional Black Caucus Awards Dinner in 2002. Hughes moved to D.C. from Omaha, Nebraska, in 1971, becoming a lecturer in the newly established School of Communications at Howard University. She was a general sales manager at WHUR Howard University Radio in 1973 and vice president and general manager in 1975. She purchased WOL-AM in 1980, pioneering 24-hour talk radio. Radio One went public in 1999 and is valued at more than $3 billion. D.C. native Jeff Majors studied the harp under Alice Coltrane, wife of the late jazz icon John Coltrane. Majors was a DJ at a local D.C. radio station in his early 20s. (Courtesy Ron Baker.)

Radio One CEO Cathy Hughes poses with Dr. T. D. Jakes at an event he was hosting in Washington, D.C. (Courtesy Ron Baker.)

Dr. Dorothy Height poses with Dr. T. D. Jakes and Serita Jakes at an event hosted by Dr. Jakes at the Press Club in Washington, D.C., *c.* 2002. (Courtesy Ron Baker.)

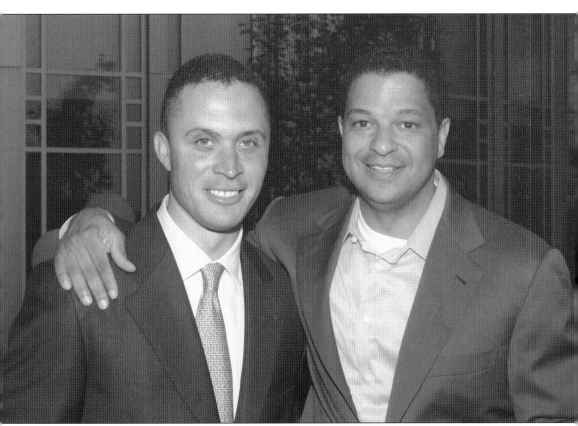

Congressman Harold Ford Jr. (D-Tennessee), at left, is joined by childhood friend Alfred Liggins, at right, at a surprise birthday party for Ford in 2004. Ford ran for the Ninth District seat held by his father, Harold Ford Sr., for 11 terms. Ford Jr. ran for and won the Ninth District seat in 1996. Ford lost his bid for a Senate seat in 2006. Alfred Liggins is the son of Radio One founder Cathy Hughes. Liggins serves at the helm of Radio One, based in Lanham, Maryland, and the TV One cable network. (Courtesy Ron Baker.)

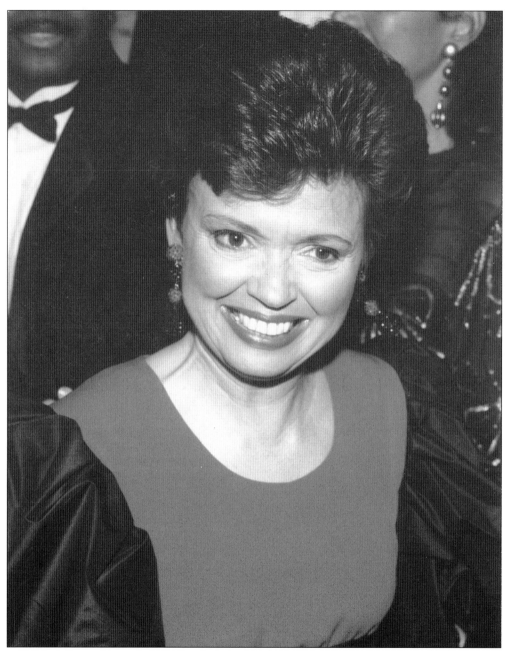

Sharon Pratt-Kelly was elected the first woman mayor of the District of Columbia and the first of any major American city. She served from 1991 to 1995. She became mayor as Sharon Pratt-Dixon and changed her name upon marrying James R. Kelly III, an African American businessman. Kelly was born in Washington, D.C. She earned a bachelor of the arts degree and a law degree from Howard University. She entered private law practice in 1971 and taught at the Antioch School of Law in Washington, D.C. She served on the Democratic National Committee from 1977 to 1990. Here she moves through the crowd during her inaugural ball in 1991. (Courtesy Ron Baker.)

Charles Bernard Rangel was born June 11, 1930, in Harlem, New York. He was elected to Congress in 1971, defeating the legendary Adam Clayton Powell in the primary. Rangel served during the Korean War in the U.S. Army from 1948 to 1952, earning a Purple Heart and Bronze Star. He earned a law degree from St. John's University. His first committee assignment was on the House Judiciary Committee, where he participated in the impeachment hearings against Pres. Richard Nixon. (Courtesy Ron Baker.)

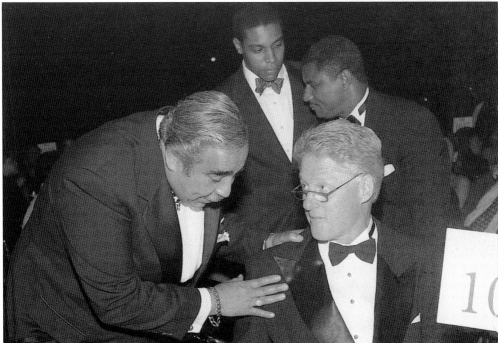

Congressman Rangel confers with President Clinton at the 1998 Congressional Black Caucus Awards Dinner. Behind Clinton on the right is Transportation Secretary Rodney E. Slater. (Courtesy Ron Baker.)

Former D.C. mayor Marion Barry attends his first event in 1990 after being released from a six-month prison stay as a result of the infamous crack cocaine sting earlier the same year. Barry arrived with his second wife, Cora Masters-Barry. Barry was elected council member of the Eighth Ward in Anacostia. (Courtesy Ron Baker.)

Roots author Alex Haley shakes the hand of the late Congressman Charles Diggs during the 1978 Congressional Black Caucus Dinner. Caucus members include, from left to right, Congressman Charles Rangel (D-New York), Congressman Perrin Mitchell (D-Maryland), Congressman Barbara Jordan (D-Texas), Congressman Ralph Metcalfe (D-Illinois), Congressman August Hawkins behind Haley (D-California), Congressman Cardis Collins (D-Ohio), U.N. Ambassador Andrew Young, and Congressman William Clay (D-Missouri). (Courtesy Ron Baker.)

From left to right, Congressman Charles Diggs (D-Michigan) poses with Benjamin Hooks and Clifford Alexander. Hooks, an attorney, was the first African American FCC commissioner, and Alexander was tapped by President Carter to be the first African American secretary of the army. They attended this event at the Johnson Publishing offices in Washington, D.C., in 1977. (Courtesy Ron Baker.)

Congressman Diggs (left) is distracted during an interview with WTOP-9 reporter Bob Strickland at the 1977 Congressional Black Caucus Dinner. Diggs, the first black congressman elected from the state of Michigan, served 26 years in Congress. (Courtesy Ron Baker.)

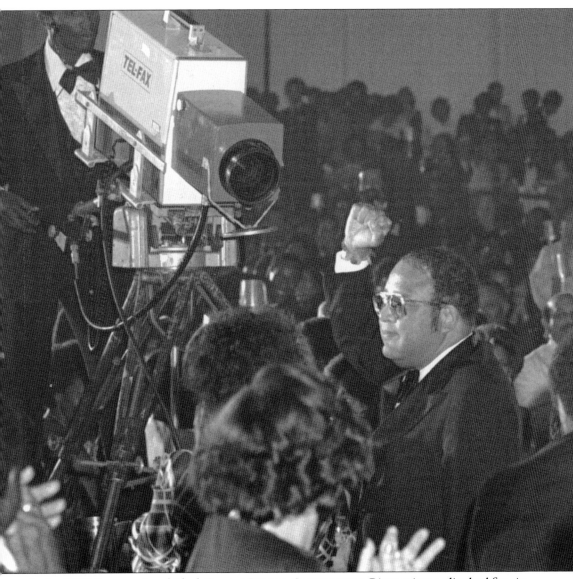

At the 1979 Congressional Black Caucus Dinner, Congressman Diggs raises a clinched fist. At that time, Diggs was fighting charges of operating a kickback scheme while facing censure in the House. He was censured by the House in 1980 and resigned after being convicted of operating a kickback scheme. He died from a stroke at the age of 75. (Courtesy Ron Baker.)

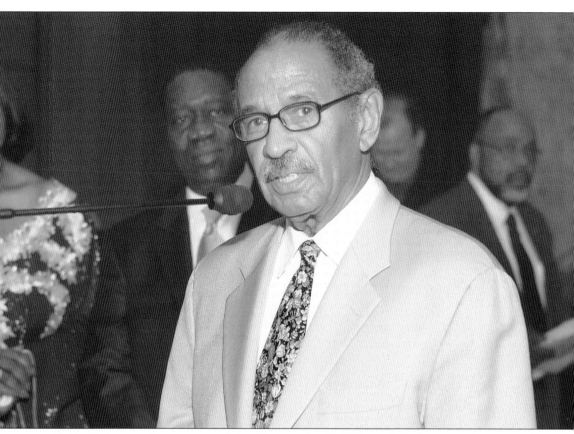

In his 21st term, Congressman John Conyers Jr. (D-Michigan) is the second most senior member of the House and is the first African American Democratic Leader of the House Committee on the Judiciary. He is a founding member and dean of the Congressional Black Caucus. (Courtesy Ron Baker.)

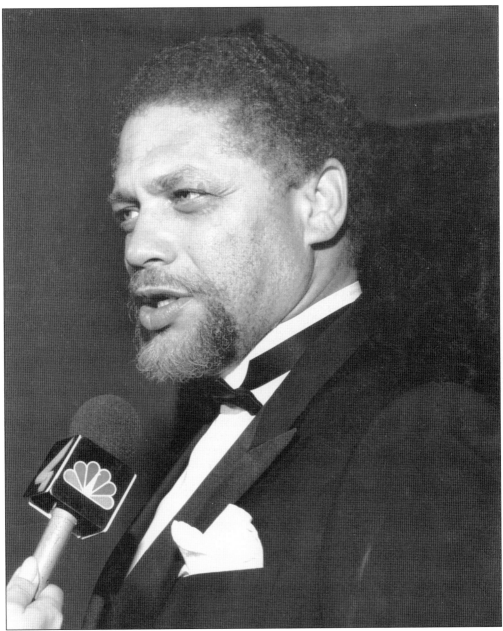

Congressman George Thomas "Mickey" Leland attended what would be his final Congressional Black Caucus Dinner in September 1988. In this photograph, he is being interviewed by WRC-4 news reporter Wendy Reiger. Leland was born November 27, 1944, and earned his bachelor of science degree from Texas Southern University. He was elected to the Democratic National Convention in 1976 and was elected to the U.S. Congress in 1978 from the 96th District in Texas. He served until his death on August 7, 1989, in an aircraft crash near Gambela, Ethiopia, while en route to a United Nations refugee camp near the Sudan-Ethiopia border. He was the chairman of the Select Committee on Hunger (98th through 100th Congresses), freshman majority whip (96th Congress), and at-large majority whip (97th through 100th Congresses). (Courtesy Ron Baker.)

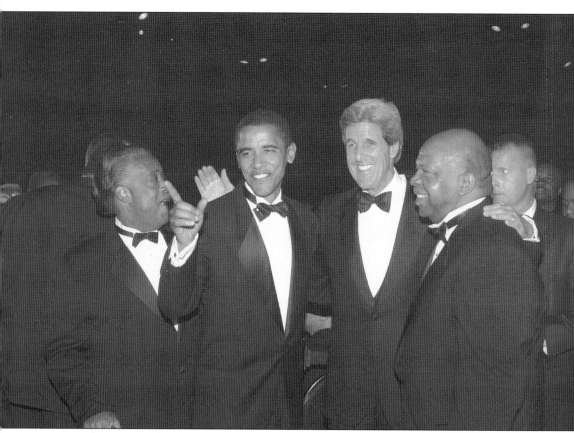

Illinois U.S. Senator Barack Obama shares the spotlight with seasoned politicians and activists at the 2004 Congressional Black Caucus Awards Dinner. From left to right are activist Rev. Al Sharpton, Obama, presidential candidate Sen. John Kerry (D-Massachusetts), and Baltimore, Maryland, congressman Elijah Cummings (D-Maryland). A civil rights attorney and leader in the Illinois State Senate, Obama was sworn into office January 4, 2005, as only the third African American in the U.S. Senate since Reconstruction. Obama graduated from Harvard Law School in 1991, where he was the first African American president of the *Harvard Law Review*. In several television interviews, Senator Obama has expressed interest in seeking the Democratic nomination for president of the United States in 2008. (Courtesy Ron Baker.)

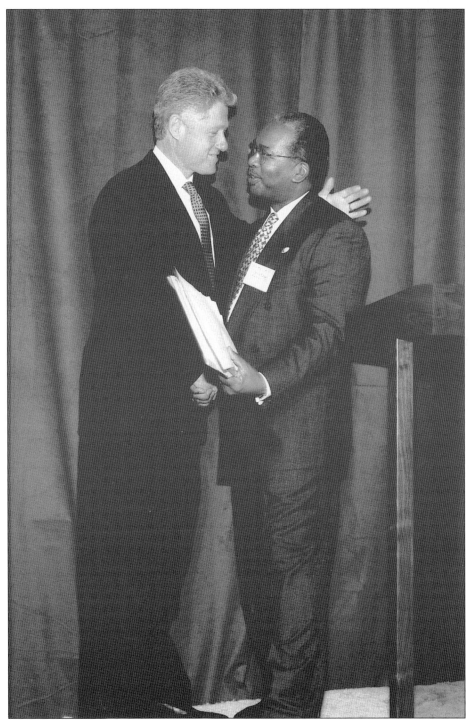

President Clinton greets his friend and advisor Ernie Green during a fund-raiser in 1995. Green, a successful businessman, was one of the original Little Rock Nine who integrated Central High School in Arkansas in 1957 and was the school's first black graduate. (Courtesy Ron Baker.)

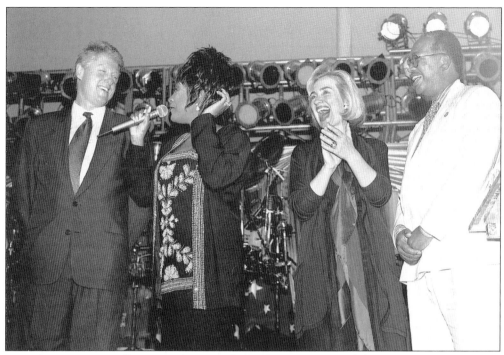

R&B diva Pattie LaBelle serenades President Clinton at a 1996 fund-raiser in Oxon Hill, Maryland. Along with the president are Hillary Clinton and advisor Ernie Green. (Courtesy Ron Baker.)

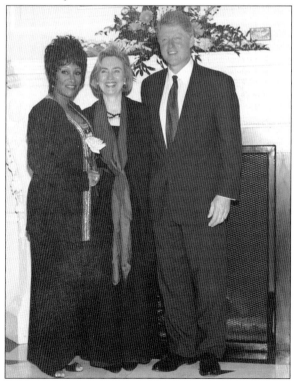

Songstress Pattie LaBelle is the headliner for Pres. Bill Clinton's fund-raiser in Oxon Hill, Maryland, outside of Washington, D.C., in 1994. Along with the president is First Lady Hillary Clinton, who would later run for and be elected U.S. senator from the state of New York in January 2001. She easily won reelection to the Senate in November 2006 and is considered a frontrunner for the 2008 Democratic nomination. (Courtesy Ron Baker.)

As commerce secretary in the Clinton administration, Ronald Brown was the first African American to be appointed to the post. Here Secretary Brown (left) poses with media relations legend Ofield Dukes at Brown's home in 1993. Dukes organized the Black Public Relations Society of Washington. He also published the *Washington North Star*, which was the first black-owned daily newspaper in Washington, D.C. (Courtesy Ron Baker.)

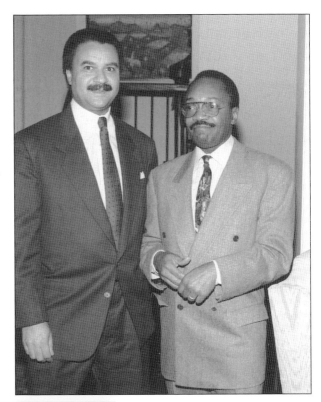

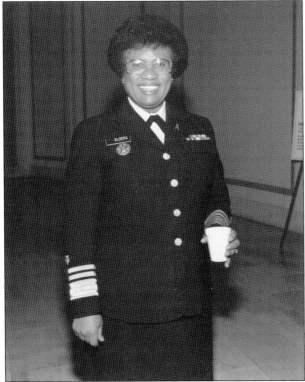

Surgeon General Joycelyn Jones Elders, born in Schall, Arkansas, in 1933, served in the Clinton administration from September 1993 until she was dismissed in 1994. She was dismissed for comments she made during a world AIDS conference. Always outspoken, Elders angered conservatives with her support of sex education and the distribution of condoms in schools. (Courtesy Ron Baker.)

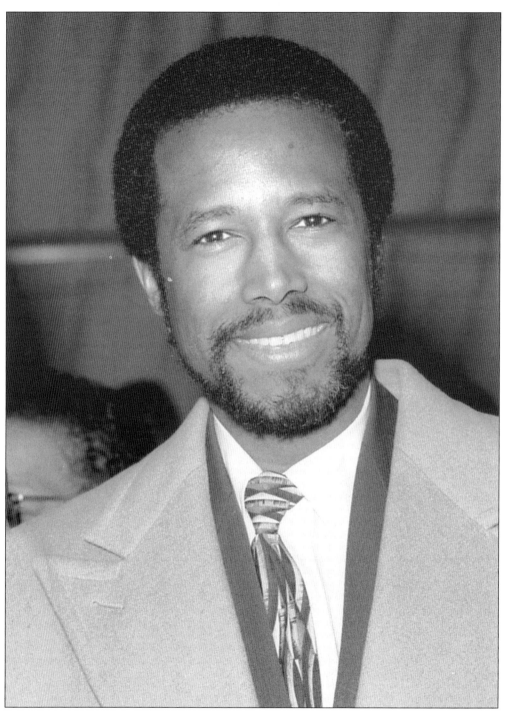

Dr. Benjamin S. Carson Sr., director of the Division of Pediatric Neurosurgery at Johns Hopkins since 1984, gained public notoriety in the 1990s after separating South African twin boys who were joined at the head. In this photograph, he poses during a charitable event *c.* 1999. Dr. Carson has written over 90 neurosurgical publications and has been awarded over 24 honorary degrees. Dr. Carson is also a best-selling author. (Courtesy Ron Baker.)

Surgeon General David Satcher participates in a health forum at the 2001 Congressional Black Caucus Legislative Conference. Dr. Satcher was the 16th surgeon general of the United States from 1998 until 2002. From 1993 to 1998, he held the posts of director of the Centers for Disease Control and Prevention and administrator of the Agency for Toxic Substances and Disease Registry. Dr. Satcher graduated from Morehouse College in Atlanta in 1963 and received his M.D. and Ph.D. from Case Western Reserve University in 1970. (Courtesy Ron Baker.)

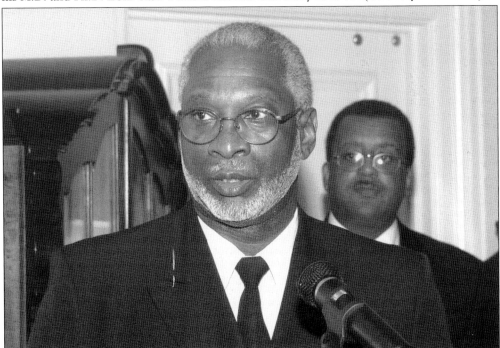

Dr. Satcher talks to attendees in support of the organization MESAB (Medical Education for South African Blacks) in 2001. (Courtesy Ron Baker.)

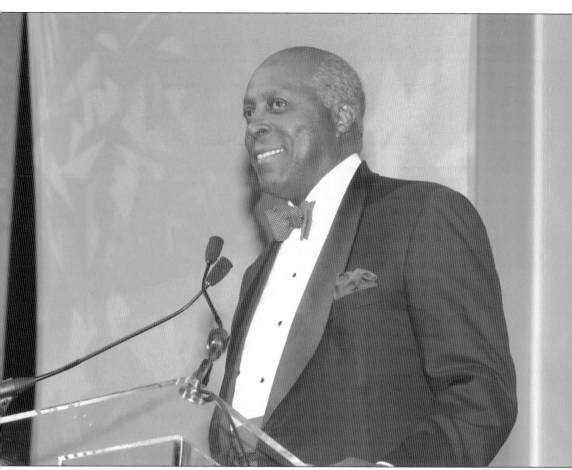

Lawyer and Washington power broker Vernon Jordan speaks to the African American Real Estate Professionals in 2005 at their annual dinner. Jordan joined the civil rights movement in 1961 and helped organize the integration of the University of Georgia. He served as field secretary for the NAACP and was a delegate to Pres. Lyndon Johnson's White House Conference on Civil Rights. He was appointed president and CEO of the National Urban League in 1971. An attempt was made on his life in May 1980 by a white supremacist who shot him. (Courtesy Ron Baker.)

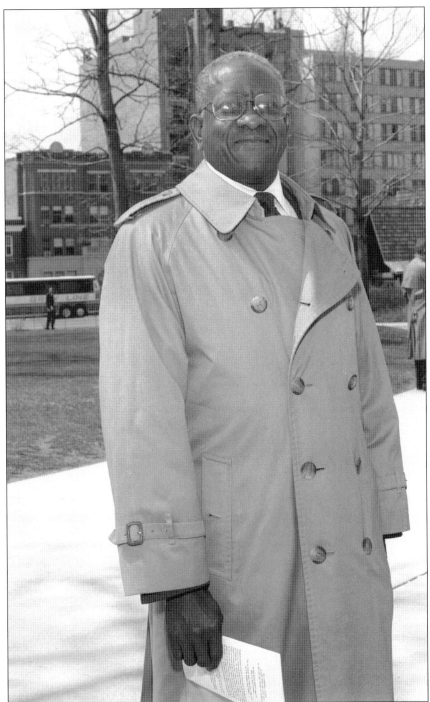

Dr. Andrew Brimmer, an Ivy League–trained economist and the first African American Federal Reserve Board member, is best known for his appointment as chair of the D.C. Financial Control Board in 1995 by Pres. Bill Clinton. D.C. faced a $722-million deficit and lost its borrowing privileges. Brimmer is pictured attending the funeral of Commerce Secretary Ronald H. Brown in Washington, D.C., in 1996. (Courtesy Ron Baker.)

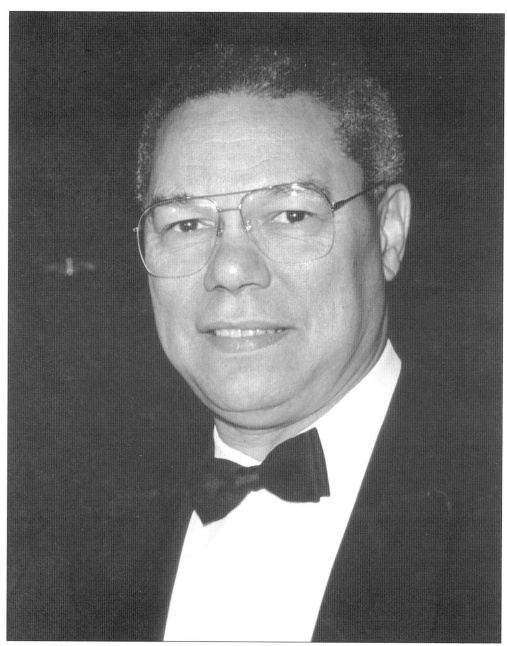

Enjoying an evening out at a social event in Washington, D.C., Gen. Colin Powell stops for a photo opportunity. Gen. Colin Luther Powell, U.S. Army (retired), was appointed chairman of the Joint Chiefs of Staff from 1989 to 1993 by Pres. George Herbert Walker Bush. Powell is the highest-ranking African American in the military history of the United States. Colin Powell was nominated for and confirmed as the 65th U.S. Secretary of State, serving from January 2001 to January 2005. Powell was born in 1937 in the Bronx, New York. (Courtesy Ron Baker.)

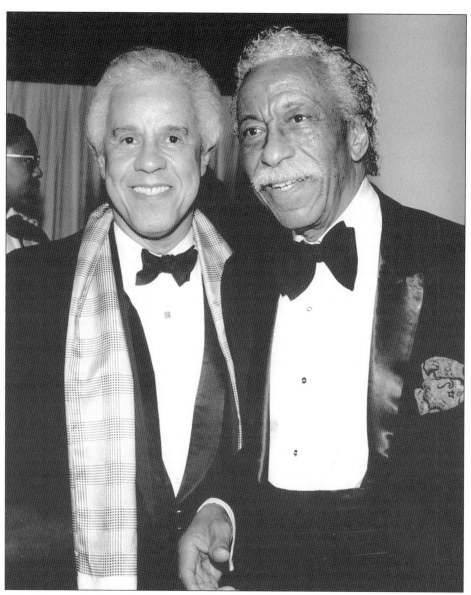

Virginia governor L. Douglas Wilder and famed photographer/film director Gordon Parks Sr. are seen here attending one of the many presidential balls for Pres. Bill Clinton on January 20, 1993. Governor Wilder was the first-ever African American elected to the governor's office in the United States. Wilder was elected lieutenant governor in 1985 and then was elected to the post of governor in 1989. He was elected mayor of Richmond in November 2004. Gordon Parks Sr. was born in 1912 in Kansas. In 1936, Parks purchased a used camera, and in 1938, he decided on a career in photography. He convinced a white clothing store owner, with the help of the owner's wife, to allow him to photograph their dresses with models and put the prints on display in the store. Parks trained as a photojournalist in Washington, D.C. In 1941, he was the first black photographer to work for *Life* and *Vogue* magazines. He is best known for his photographic social commentary (he also worked as a photographer for the USDA) and directing the blockbuster film *Shaft* in 1971. He died on March 7, 2006. (Courtesy Ron Baker.)

Bernice Baker, mother of Ronald and Donald Baker, is shown in this photograph. Mrs. Baker, who worked for the government, and her husband Oscar, a business owner, adopted the twins and encouraged the boys to pursue their hobby for taking photographs of friends and family. The seed the Bakers planted have taken the twins from the White House to the personal houses of this country's most celebrated performers. Sadly, in 1969, Bernice and Oscar Baker passed away within six months of each other. (Courtesy Ron Baker.)

Donald Lee Baker, like his identical twin brother Ron Baker, is a celebrity videographer and photographer. A product of Washington schools, Baker held many jobs in the private sector and served in the army—but in 1975, his passion for photography led him to open a business where he photographs newsmakers and high profile politicians. (Courtesy Ron Baker.)

Three

NOTABLES

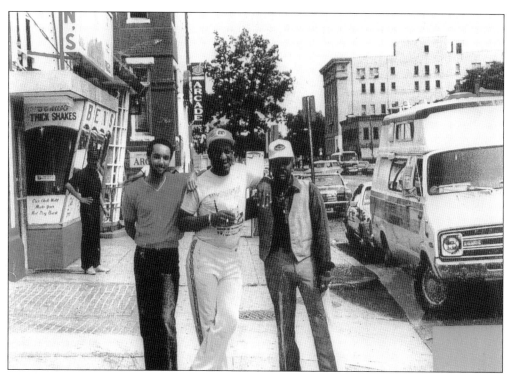

Dr. Bill Cosby (center) stands with two associates in front of Ben's Chili Bowl in 1983. Dr. Cosby courted his wife, Dr. Camille O. Cosby, at Ben's Chili Bowl when she was a Howard University student. Ben's Chili Bowl was one of a very few businesses that was able to keep their doors open during the riots that followed Dr. Martin Luther King's death. (Courtesy Nizam Ali.)

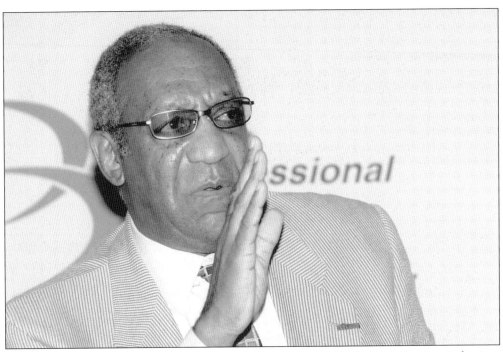

Bill Cosby speaks at a Congressional Black Caucus forum in 2004. (Courtesy Ron Baker.)

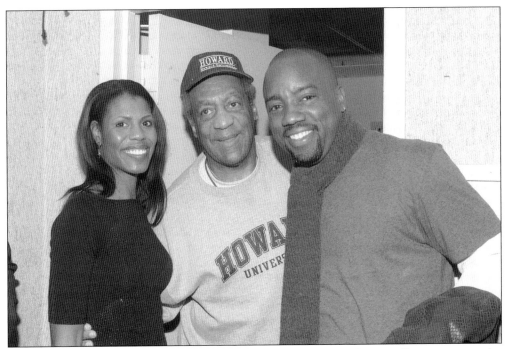

Bill Cosby (center) steps out of a meeting with D.C. mayor Anthony Williams to greet the *Apprentice*'s Omarosa Manigault Stallworth and stage and television actor Malik Yoba during a Tom Joyner Sky Show stop in Washington, D.C., in 2004. (Courtesy Ron Baker.)

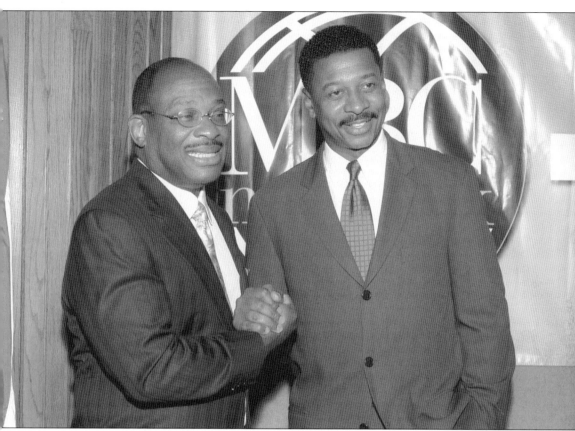

In 2004, attorney Willie Gary, founder and chief executive officer of Major Broadcasting Cable Network, appoints filmmaker, comedian, actor, producer, and director Robert Townsend, owner of Tinsel Town Productions, president of the entertainment division to help create family-oriented programming for the fledgling network. Townsend is known for his HBO specials and his successful comedies such as *Hollywood Shuffle* and *Meteor Man*. (Courtesy Ron Baker.)

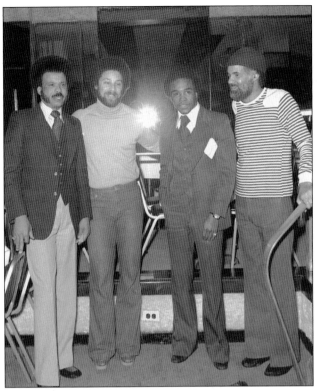

From left to right, Washington icon Petey Green is joined by sportscaster Glenn Harris, boxing legend Sugar Ray Leonard and WRC-4 TV producer Dewey Hughes at a birthday celebration for Green in 1978. Green was known for championing the causes of the poor and elderly. Green came from a poverty- and crime-laced background but turned his life around to become a beloved leader in the Washington community. He had his own radio show as well as a television show on WDCA-20 in D.C., which was broadcast to 5.5 million homes in 53 cities by BET. Green died of cancer in 1984. A film has been completed about his life with actor Don Cheadle playing the lead role. The film is due out in 2007. (Courtesy Ron Baker.)

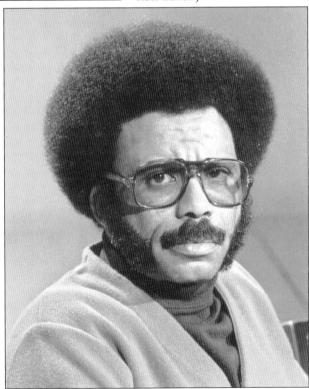

This photograph shows Petey Green on the set of the *Petey Green Show* in 1978. (Courtesy Ron Baker.)

J. C. Hayward poses during the One and Only 9 Awards in 1989. Hayward started with Channel 9 in 1971 and continues to anchor the afternoon and early evening news broadcasts. (Courtesy Ron Baker.)

Actress, dancer, director, and choreographer Debbie Allen (left) stands alongside Washington, D.C.'s WJLA-TV 7 news anchor Maureen Bunyan as they participate in an event hosted by the National Council of Negro Women in 2004. (Courtesy Ron Baker.)

From left to right, actress Debbie Allen (a graduate of Howard University), Time Warner CEO Richard D. Parsons, and DePasse Entertainment CEO Suzanne DePasse (who received an honorary doctorate from Howard University) pose during the celebration of Howard University's School of Media's 30th anniversary in 2004. DePasse was a vice president at Motown Records and was the mastermind behind the development of the Jackson 5. (Courtesy Ron Baker.)

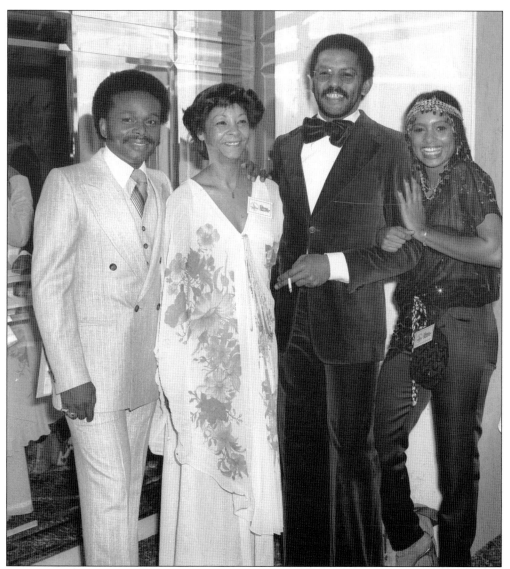

Standing with Mr. and Mrs. Herb Feemster (left) and Linda Green (right) (Peaches and Herb), Jim Vance towers over the group. Vance anchors WRC-4 evening newscasts at 6:00 and 11:00 p.m. with Doreen Gentzler. Consistently number one in the news ratings, Jim Vance began his career with the station in 1969 as a general assignment reporter. In 1972, he moved to the anchor desk. Vance was a newspaper reporter in Philadelphia and also worked in the public school system. A member of the Journalist's Hall of Fame, he has 15 Emmy Awards to his credit. He is also the distinguished recipient of the Ted Yates Award for outstanding community service. (Courtesy Ron Baker.)

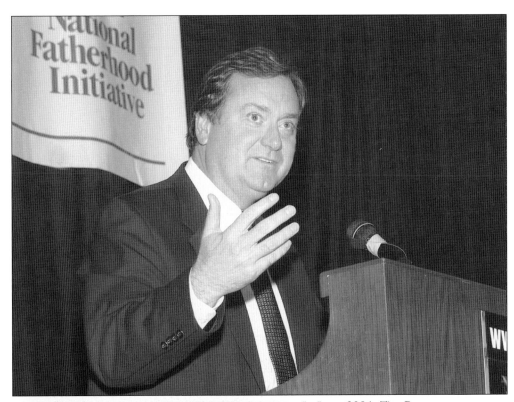

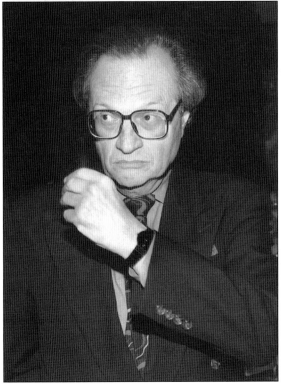

In June 2001, Tim Russert was honored at the National Fatherhood Initiative Dinner. Born in Buffalo, New York, Russert graduated from John Carroll University and Cleveland Marshall College of Law at Cleveland State University. He was admitted to the bar in New York and D.C. His 2004 biography and New York Times No. 1 bestseller *Big Russ and Me* chronicled his life growing up in a working-class neighborhood in South Buffalo. Russert is the managing editor and moderator of *Meet the Press* as well as a political analyst for *NBC Nightly News* and the *Today* show. He anchors the *Tim Russert Show* on CNBC. (Courtesy Ron Baker.)

Talk show host Larry King attends a Border Baby fund-raiser in Washington, D.C., at the River Club on K Street NW. King is best known for his one-on-ones with some of the most prominent celebrities and icons in the world. (Courtesy Ron Baker.)

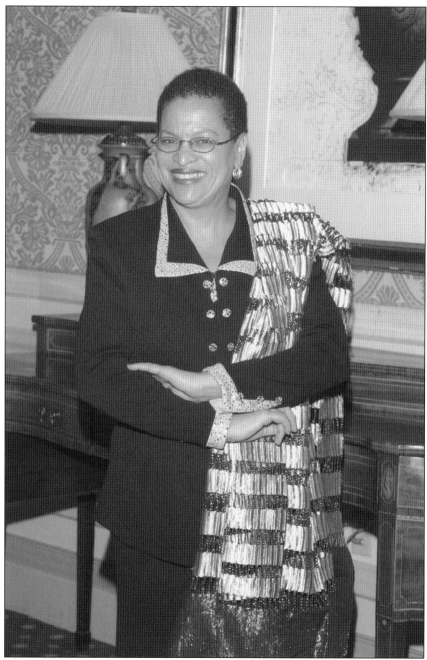

Dr. Julianne Malveaux attends the 30th Anniversary Gala for the School of Communications of Howard University in Washington, D.C., in 2004. Dr. Malveaux is an economist, author, and commentator as well as the president and chief executive officer of Last Word Productions, Inc., a multimedia production company. She received her bachelor of arts and master of arts degrees in economics and earned her Ph.D. in economics from MIT. Originally from San Francisco, she resides in Washington, D.C. Her books include *Unfinished Business* with Deborah Perry, *The Paradox of Loyalty: An African American Response to the War on Terrorism*, and *Race and Resistance: African Americans in the Twenty-First Century*. (Courtesy Ron Baker.)

Saxophonist Grover Washington Jr. (left) shares a moment and his alto sax with BET's *Video Soul* veejay Donnie Simpson on the set of *Video Soul* in 1988. Washington was there to received an award from fellow musicians Walter Beasley and Najee. (Courtesy Ron Baker.)

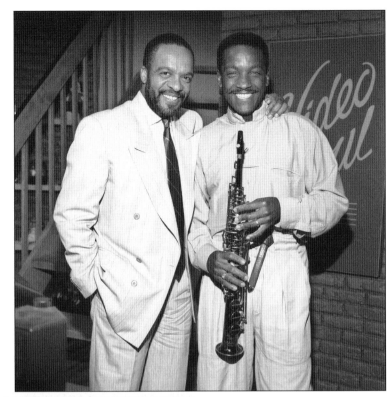

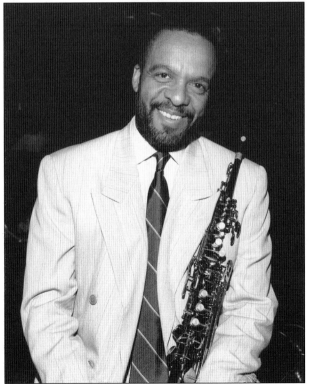

In 1988, saxophonist Grover Washington Jr. was a guest in the BET greenroom while waiting to go on *Video Soul* with Donnie Simpson. A jazz music legend, Washington hit the music airwaves in 1971 and by 1980 had won two Grammys for his album *The Winelight*. Washington also played for President Clinton's 50th birthday celebration at Radio City Music Hall. Sadly Grover Washington Jr. died suddenly in December 1999 while taping an appearance on CBS's *The Saturday Early Show*. He was 56. (Courtesy Ron Baker.)

WPGC-95 radio DJ Donnie Simpson prepares to present an award to hip hop artist LL Cool J at the 2003 NABOB (National Association of Black Owned Broadcasters) Awards Dinner. (Courtesy Ron Baker.)

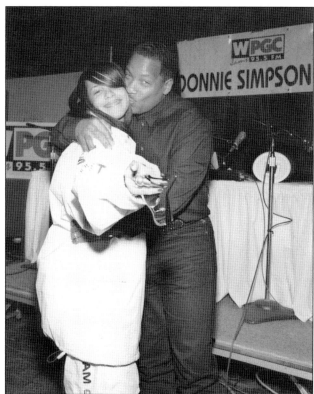

WPGC DJ and former BET veejay Donnie Simpson hugs the late singer and actress Aaliyah during the *Donnie Simpson Morning Show*'s Jammy Awards in 1997. (Courtesy Ron Baker.)

One-hit wonder Oran "Juice" Jones (left) of "Walking in the Rain" fame poses with New York DJ and veejay Frankie Crocker at a NABOB awards dinner in 1992. Crocker died of cancer in 2001. (Courtesy Ron Baker.)

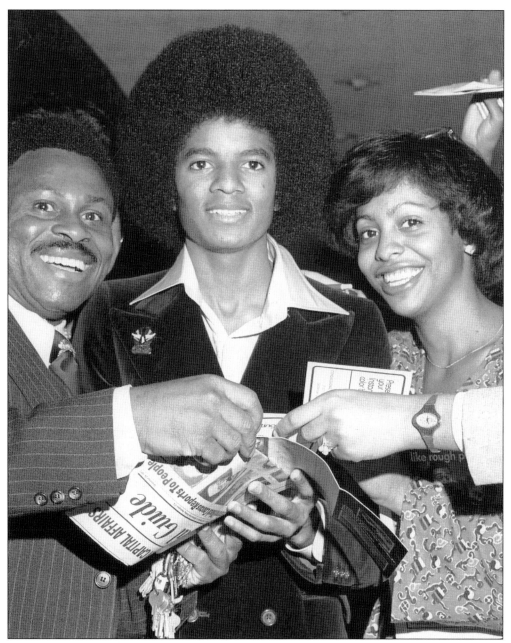

In 1977, Michael Jackson attended a Congressional Black Caucus Dinner. Fans immediately swarmed him in the lobby of the Washington Hilton Hotel. Within 18 months, Jackson won international fame following the release of his solo album *Off the Wall*. (Courtesy Ron Baker.)

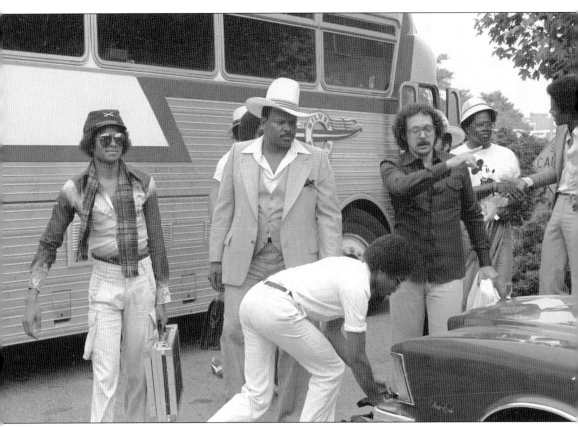

The Jacksons arrive in New Carrollton, Maryland, at the then Sheraton Hotel. Michael walks alongside security carrying his case as Randy picks up his bags. The Jacksons were on their 1979 United States tour. (Courtesy Ron Baker.)

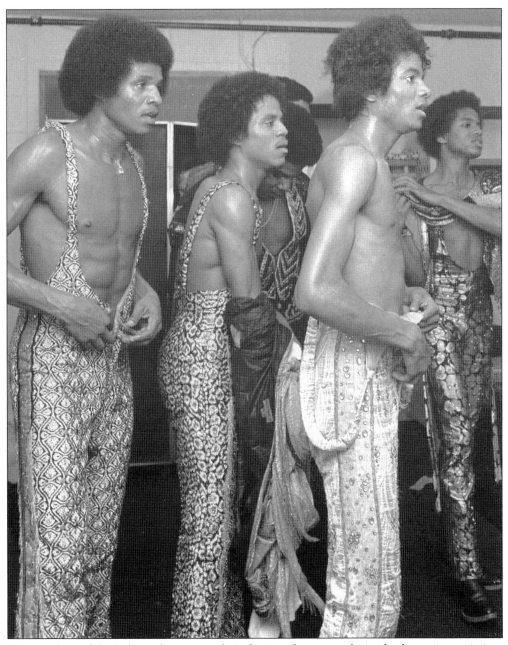

The members of the Jacksons listen intently to their road manager during backstage intermission. From left to right are Jackie, Marlon, Tito, Michael, and Randy. (Courtesy Ron Baker.)

Michael is backstage after arriving at the Capital Center prior to the concert. To his left is Jackie. (Courtesy Ron Baker.)

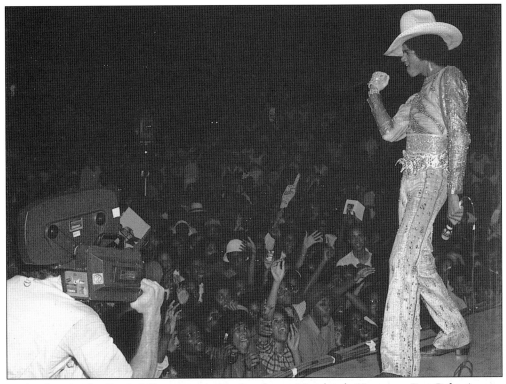

Michael rocks the Capital Center crowd in Landover, Maryland. (Courtesy Ron Baker.)

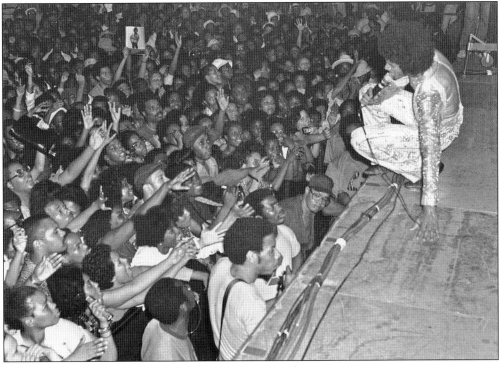

Michael ventures out to the crowd. (Courtesy Ron Baker.)

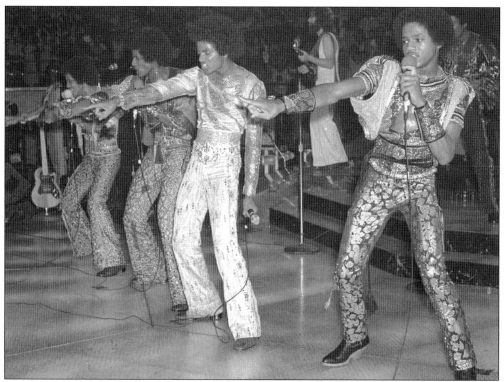

This photograph shows the Jackson family performing their famous choreography move. (Courtesy Ron Baker.)

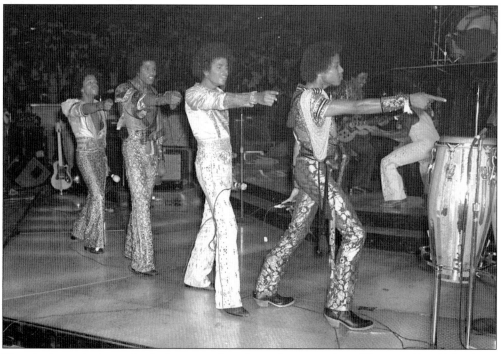

The photograph shows the Jacksons performing a dance routine. (Courtesy Ron Baker.)

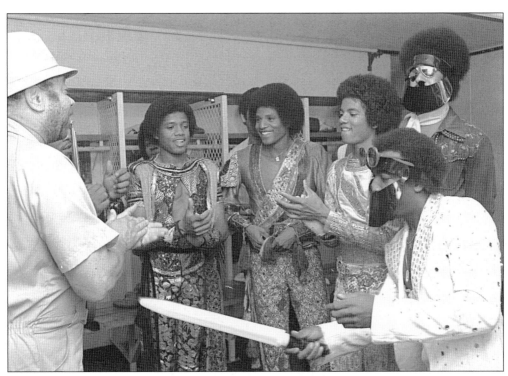

The Jacksons and their band members receive one more motivational speech from their road manager before going out for the second half of the show. (Courtesy Ron Baker.)

The Jacksons pose with singer/actress Stephanie Mills backstage after their show. Mills was famous for her Tony Award–winning performance in the stage production *The Wiz* at the age of 15. A native of Brooklyn, New York, Mills started singing in church. At 11, she won amateur night at the Apollo theater for six consecutive weeks. She received a Grammy and an American Music Award with 5 best-selling albums and 10 Billboard No. 1 singles. (Courtesy Ron Baker.)

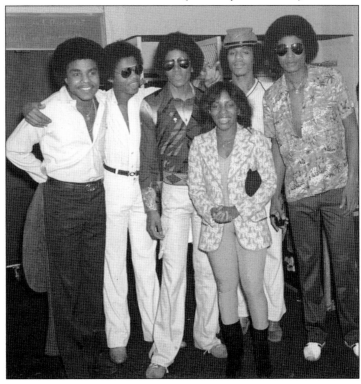

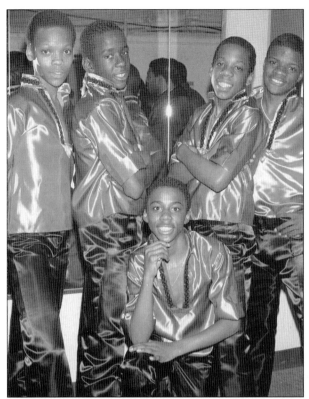

In 1984, New Edition was sweeping the country with their hit "Candy Girl." Washington, D.C., was one of their first tour stops, and they performed to a sold-out crowd at the Washington Coliseum. They didn't have a live band at the time, but they sang live with a taped instrumental background track. The fans did not seem to notice. The group consisted of, from left to right, (kneeling) Ralph Tresvant; (standing) Ronnie DeVoe, Bobby Brown, Michael Bivins, and Ricky Bell. Washington, D.C.'s own Johnny Gill later joined the group in the 1990s, replacing singer Bobby Brown. (Courtesy Ron Baker.)

New Edition performed in sync and in style at the Washington Coliseum in 1984. (Courtesy Ron Baker.)

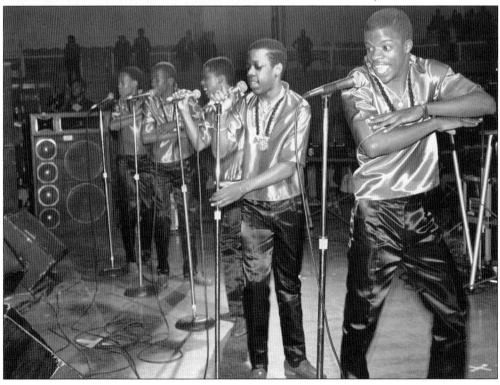

One of the artists who put rap on the map, rapper Kurtis Blow wows a D.C. audience during a 1979 concert. Blow was the first rapper to be signed to a major record label (Mercury Records). Blow was famous for the first certified gold rap single, "The Breaks." (Courtesy Ron Baker.)

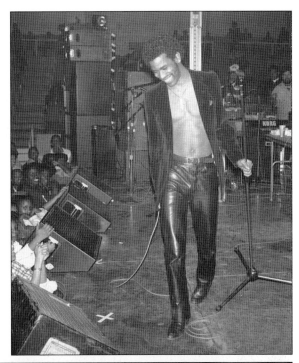

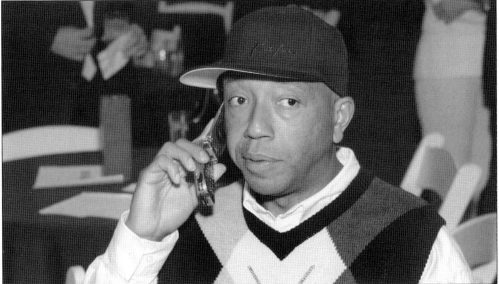

Hip hop mogul Russell Simmons takes a moment to handle business prior to chairing a private fund-raiser for Foundation for Ethnic Understanding in 2005. Born in 1957 in Queens, New York, Simmons cofounded Def Jam Records with Rick Rubin in 1984. The Beastie Boys and LL Cool J were among the first artists they signed. Simmons attended City College in New York but left to begin promoting local rap acts including Kurtis Blow and Run-DMC. He is also the founder of Rush Communications, Phat Farm clothing, and Def Comedy Jam, among his numerous other ventures. Simmons, a cultural visionary, sold his stake in Def Jam Records to Universal Music Group in 1999 for $100 million. His philanthropic activities include a campaign to educate youth on the importance of money management. (Courtesy Ron Baker.)

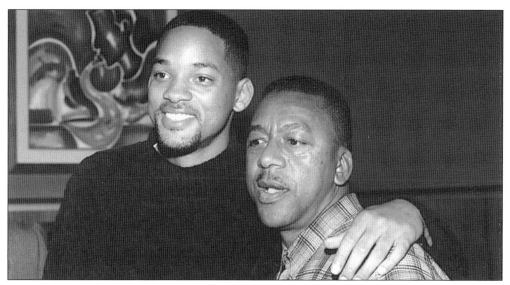

Rapper/actor Will Smith (left) came to town in 1998 to support Black Entertainment Television founder Robert Johnson's new theme restaurant. The BET Soundstage was a 365-seat restaurant designed to look and feel like an actual soundstage. The facility contained three 70-foot video screens and another 42 video monitors scattered throughout the 12,000-square-foot building. Johnson duplicated his concept in Disney World. The Largo, Maryland, facility was closed in 2002 and converted into Jasper's restaurant. The Disney World BET Soundstage is still open. In 2001, Robert Johnson sold BET Holdings, Inc., to Viacom for nearly $3 billion in stock. Johnson and his former wife, cofounder of BET Sheila Johnson, divorced in 2002. She owns the Washington Mystics basketball team and is planning to open the Salamander Inn, which will be an upscale bed-and-breakfast inn located in Middleburg, Virginia. (Courtesy Ron Baker.)

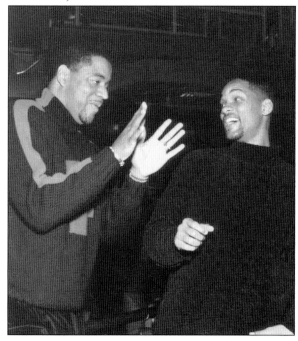

Will Smith (right) jokes with personality Ed Lover (formerly of MTV) at the BET Soundstage in 1998. (Courtesy Ron Baker.)

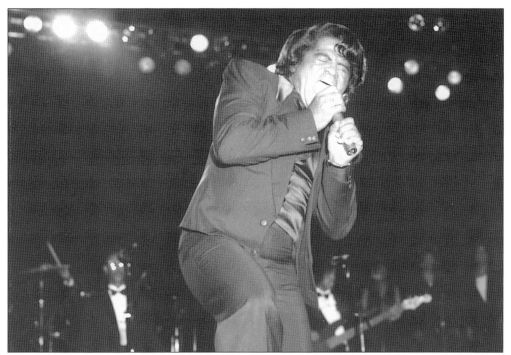

The "godfather of soul" James Brown performs for the National Association of Black Owned Broadcasters at the Sheraton-Washington Hotel in 1993. Brown passed away over Christmas 2006. (Courtesy Ron Baker.)

Music legend Chaka Khan (left) defers to smooth-singing Musiq during a concert performed at the Marriott Wardman Park. Khan invited Musiq onto the stage with her as thunderous applause arose from the audience. (Courtesy Ron Baker.)

Disco queen Donna Summer (right) shares a moment with WHUR 96.3 and Radio One on-air personality Robin Holden while backstage in Summer's dressing room in 1978 at Painter's Mill outside of Washington. Known for her hit signature song "Love To Love You," Donna Summer appeared in the 1978 disco movie *Thank God It's Friday* and sang the hit "Last Dance" from the popular soundtrack. (Courtesy Ron Baker.)

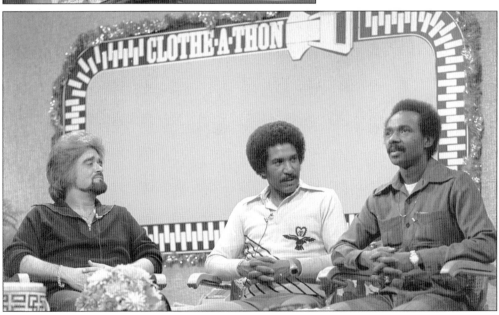

Grammy Award–winning writer, producer, and performer Van Allen McCoy (right) sits in with Friday Night Special's Wolfman Jack (left) and sitcom star Adam Wade for a WJLA-7 TV Clothe-A-Thon during the holiday season in Washington, D.C., in 1976. Those close to McCoy, a very private man, say he had a big heart and always thought of others before himself. Photographer Ron Baker got his first opportunity to shoot an album cover for a major artist and record label because of McCoy. McCoy was also the godfather to Baker's beautiful daughter Kellee. (Courtesy Ron Baker.)

Van McCoy shares a moment with his goddaughter, Kellee Genean Baker, in 1978 as they hold his 1975 Grammy. Van did not get an opportunity to see Kellee again as he would pass away less than seven months later. Ironically, Kellee would learn to play the organ and have a passion for music. She went on to graduate from Howard University School of Law. (Courtesy Ron Baker.)

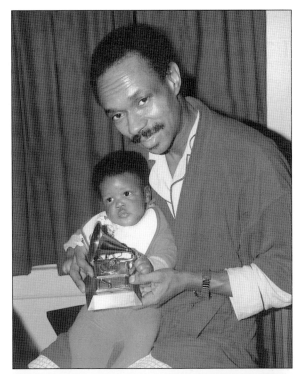

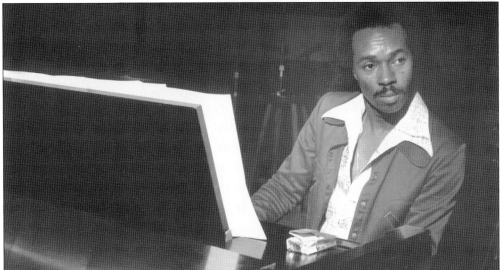

Van rehearses prior to a performance at the Naval Academy in Annapolis, Maryland, in 1976. Van was born January 6, 1940, in Washington, D.C., to Lillian R. and Norman S. McCoy Sr. Van grew up with the likes of Delegate Walter E. Fauntroy, who sang with Van. Van was encouraged by his mother to master the piano, and he used his talent to write more than 700 copyrighted songs. In 1975, Van received Best Pop Instrumental Performance for his song "The Hustle," which would become the soundtrack for the disco era. He also wrote the soundtrack for the television mini-series *A Woman Called Moses* starring Cicely Tyson as Harriett Tubman, who helped more than 150 slaves gain their freedom via the underground railroad. Van died July 6, 1979, at his home in Englewood, New Jersey, of heart failure. (Courtesy Ron Baker.)

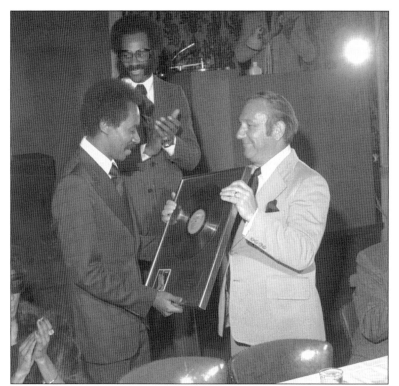

Van McCoy receives a gold record from Swartz Brothers Distribution for sales of 500,000 for his album *Disco Baby* during a ceremony held at the Sagittarius Club in Washington, D.C., on Van McCoy Day, April 27, 1976. (Courtesy Ron Baker.)

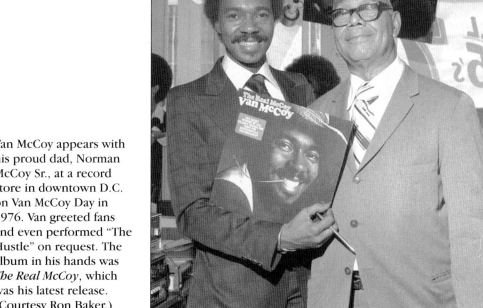

Van McCoy appears with his proud dad, Norman McCoy Sr., at a record store in downtown D.C. on Van McCoy Day in 1976. Van greeted fans and even performed "The Hustle" on request. The album in his hands was *The Real McCoy*, which was his latest release. (Courtesy Ron Baker.)

Actress Cicely Tyson smiles while attending a 1977 Congressional Black Caucus Dinner. Known for her landmark roles on screen and television—including the 1974 television special *The Autobiography of Miss Jane Pittman* and *Sounder*, Tyson has appeared in more than 75 television shows and films during her career. She was raised in Harlem, New York; her parents were from the Caribbean island of Nevis. Tyson modeled for *Ebony Magazine* in 1957 and began acting in off-Broadway productions. She was nominated for an Academy Award for her performance in the 1972 film *Sounder* opposite the late Paul Winfield. In 1981, she married jazz legend Miles Davis. She also cofounded the Dance Theatre of Harlem with Arthur Mitchell. (Courtesy Ron Baker.)

Cicely and the late Brock Peters pose during a Congressional Black Caucus event. Peters was best known for his portrayal of Johnny, a character accused of assaulting a white woman, in the landmark 1962 film *To Kill A Mockingbird*. Peters also appeared in many other films, including *Carmen Jones* with Dorothy Dandridge and Harry Belafonte, *Porgy and Bess*, *Star Trek IV: The Voyage Home*, and the television mini-series *Roots: The Next Generation*. He died of pancreatic cancer on August 23, 2005, in Los Angeles at the age of 78. (Courtesy Ron Baker.)

Mayor Walter E. Washington of Washington, D.C., throws up the victory sign during a run for a third term as mayor of the Capital City in 1978. With him is Herb Feemster (left) and Linda Green (right), better known as Peaches and Herb. (Courtesy Ron Baker.)

Shortly after signing on as the new Peaches, Linda Green and Herb pose for promotional photographs in 1976. The early style for Peaches did not include the cornrows and beads. Their No. 1 hit "Reunited" in 1978 was a follow-up to their first big disco hit "Shake Your Groove Thing," which was only released on 12-inch vinyl. Ron Baker was the first photographer for the new Peaches and Herb album; he says the experience was a thrilling one. (Courtesy Ron Baker.)

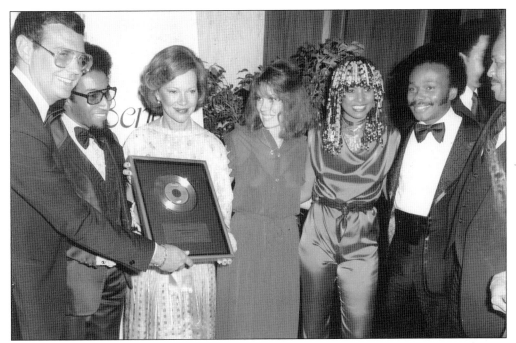

Peaches and Herb receive their gold record in 1978 from the president of Polydor Records (far left). Also pictured from left to right are Freddie Perrin, their writer and producer; First Lady Rosalind Carter; Valerie Perrin, songwriter; Peaches; Herb; and Mayor Marion Barry. (Courtesy Ron Baker.)

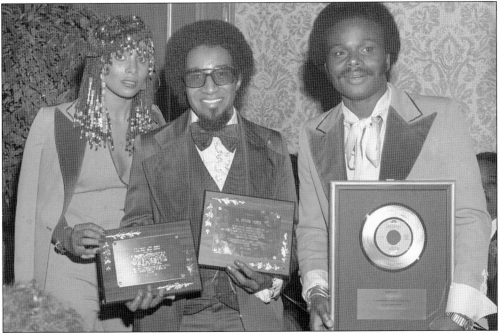

Peaches, producer Freddie Perrin (center), and Herb show off their awards hardware at a industry party held in Washington, D.C., in 1978 for their No. 1 hit "Reunited." (Courtesy Ron Baker.)

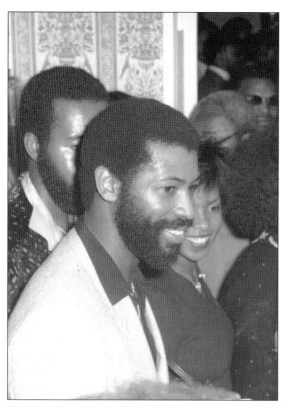

Teddy Pendergrass attends a 1977 reception during the Congressional Black Caucus Legislative Week in Washington, D.C. At the time, Pendergrass was one of the hottest artists on the R&B and pop charts with his smooth and silky ballads. Pendergrass was paralyzed from the waist down in an automobile accident in 1982. (Courtesy Ron Baker.)

Evelyn "Champagne" King performs at the Washington Coliseum. Known for her disco dance songs, King was discovered while cleaning the offices of Gamble and Huff, who created the "Sound of Philadelphia" with such acts as the O'Jays, Teddy Pendergrass, and Billy Paul of "Me And Mrs. Jones" fame. In 1977, King had a successful hit record with "Shame." (Courtesy Ron Baker.)

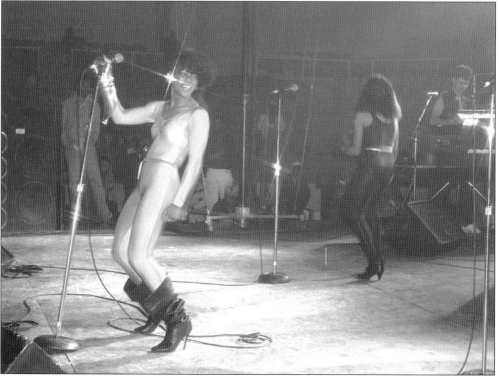

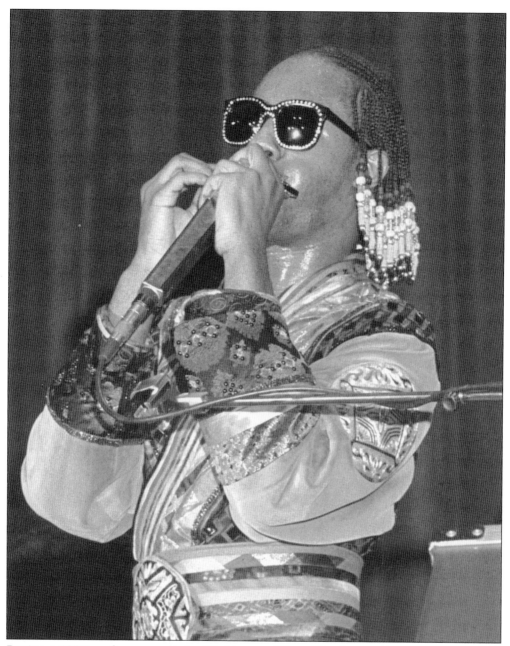

During a 1977 performance at the Washington Hilton Hotel in Washington, D.C., Stevie Wonder breaks out the harmonica. Born Steveland Morris in Detroit, Stevie was signed to Motown when he was only 12 years old. Motown released his first album, which featured a live performance of a song titled "Finger Tips." Wonder also wrote and sang the anthem "Happy Birthday" for Dr. Martin Luther King Jr.'s national holiday. (Courtesy Ron Baker.)

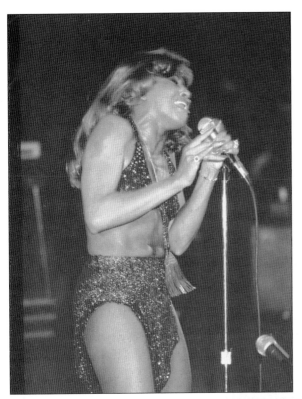

Tina Turner sings during a high-energy performance at the Capital Center in Landover, Maryland, along with Ike Turner, the Iketts, and Ike's band. They performed to a sold-out arena. Tina would leave Ike less than a year later to escape his reported abuse and drug use, as seen in the blockbuster film *What's Love Got to Do with It?* After 18 years, Tina Turner left her abusive situation with 36¢ and a gas station credit card. The film was an adaptation from Turner's book *I, Tina*. The hit song "What's Love Got to Do with It" received Record of the Year and Best Female Pop Vocal Performance honors at the 1985 Grammy Awards. A member of the Rock and Roll Hall of Fame, Turner received honors in the 1990s and in 2005 at the Kennedy Center in Washington. (Courtesy Ron Baker.)

This photograph of R&B legend Curtis Mayfield was taken during a concert at the Capital Center in Landover in October 1974. Mayfield started his career with the Impressions in 1958. In 1961, "Gypsy Woman" reached No. 2 on the R&B charts, and in 1963, "It's All Right" hit No. 1. Mayfield left the Impressions for a solo career in 1970 and released *Curtis* on his own Curtom label. In 1972, Mayfield hit No. 4 with "Freddie's Dead" and topped the Billboard's album chart for four weeks with the *Superfly* soundtrack. Curtis was paralyzed from the neck down after high winds caused a lighting rig to fall on him at a concert in Brooklyn, New York. He died December 26, 1999, in Roswell, Georgia, at the age of 57. He was inducted into the Rock and Roll Hall of Fame with the Impressions in 1991 and again as a solo artist in 1999. (Courtesy Ron Baker.)

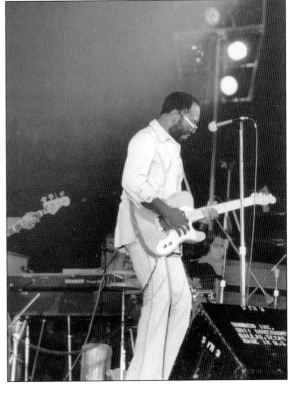

This is a 2001 photograph of the R&B group the Whispers standing with Maudeen Cooper (center). The Whispers were preparing to perform a medley of their great hits to a sold-out audience. In 1963, the group formed in the Watts neighborhood of Los Angeles and called themselves the Eden Trio. The first artists featured on Don Cornelius's Soul Train Label, the Whispers reached platinum with their 1987 No. 1 song "Rock Steady." (Courtesy Ron Baker.)

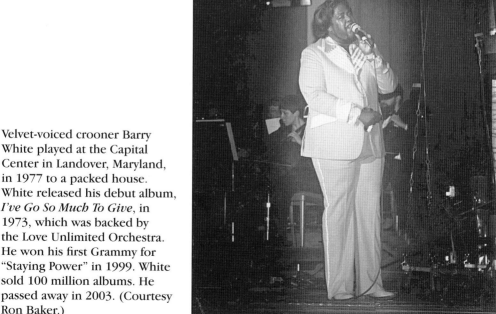

Velvet-voiced crooner Barry White played at the Capital Center in Landover, Maryland, in 1977 to a packed house. White released his debut album, *I've Go So Much To Give*, in 1973, which was backed by the Love Unlimited Orchestra. He won his first Grammy for "Staying Power" in 1999. White sold 100 million albums. He passed away in 2003. (Courtesy Ron Baker.)

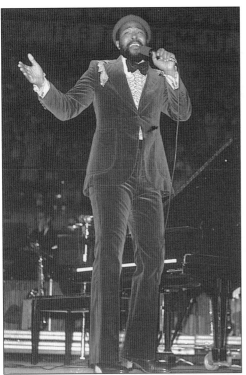

Marvin Gaye, arguably the most successful singer to hail from Washington, D.C., performs at the Capital Center outside of Washington, D.C., in 1975. A crossover icon, Gaye began his career with Motown Records in 1960 as a session drummer and vocalist. He married Berry Gordy's sister Anna in 1961 and was offered a solo recording contract. Gaye started our recording duets with the likes of Mary Wells, Kim Weston, and Tammi Terrell. In 1968, *I Heard It Through the Grapevine* became Motown's biggest selling record to date. In 1971, he released *What's Going On*, which would be his signature album. His last hit record was *Sexual Healing* in 1982. Tragically, Gaye's own father killed him on April 1, 1984. (Courtesy Ron Baker.)

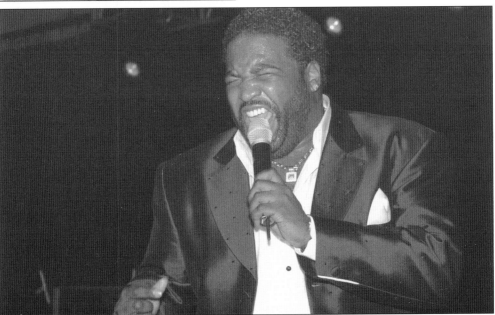

Singer Gerald LeVert performs one of his hits in Washington, D.C., in 2003. The son of O'Jays great Eddie LeVert, Gerald started his recording career as a member of the group LeVert along with his brother Sean and childhood friend Marc Gordon and scored two gold albums before going solo. His No. 1 hit "Hold On To Me" with his father, Eddie, in 1995 led to a complete album of duets. The album was entitled *Father and Son*. On November 10, 2006, Gerald died in his sleep from a heart attack. (Courtesy Ron Baker.)

In 2004, Ossie Davis was part of a Congressional Black Caucus panel in Washington, D.C. It would be his last conference, as he passed away on February 4, 2005, at the age of 87. Davis made his Broadway debut in 1946 in *Jeb*, where he met Ruby Dee. He wrote and starred in *Purlie Victorious* in 1961 and wrote *Cotton Comes to Harlem*. He worked with Dr. Martin Luther King Jr. and helped to raise money for the Freedom Riders. He eulogized both King and Malcolm X at their funerals. He received the Screen Actors Guild Lifetime Achievement Award in 1991. Here Davis and wife, Ruby Dee, are photographed before they went on stage a few moments later. (Courtesy Ron Baker.)

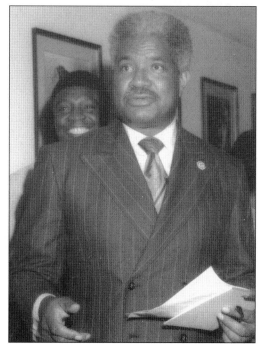

Actor, activist, and icon Ossie Davis prepares backstage before hosting at the Congressional Black Caucus Awards Dinner *c.* 1977. Davis died in February 2005 at the age of 87. (Courtesy Ron Baker.)

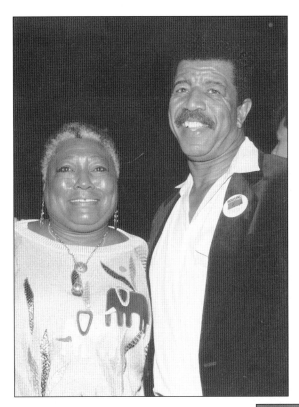

Actress Esther Rolle and actor Hal Williams attend a birthday celebration for the Reverend Jesse Jackson in 1989. Rolle, the daughter of a Florida farmer, was one of 18 children. She achieved fame in her role as Florida Evans on *Good Times*, a sitcom produced by Norman Lear. Rolle died in November 1998 at age 78; her last film role was as the maid in *Driving Miss Daisy*. Actor Hal Williams is perhaps best known for his roles as Smitty on Red Foxx's *Sanford and Son* and in the D.C.-inspired sitcom *227* opposite Marla Gibbs. (Courtesy Ron Baker.)

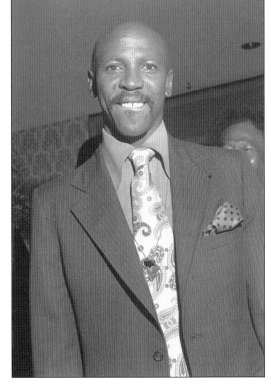

This photograph shows Academy Award–winner Lou Gossett at the 1988 Congressional Black Caucus event. Gossett won the Best Supporting Actor award for his portrayal of Gunnery Sgt. Emil Foley in *An Officer and a Gentleman* in 1982. He was also known for his role as Fiddler in the Alex Haley–inspired mini-series *Roots*. (Courtesy Ron Baker.)

Academy Award–winner Denzel Washington addresses the Northern Virginia Urban League prior to presenting awards to Coach Herman Boone and Coach Bill Yoast of T. C. Williams Senior High School in 2001. Washington portrayed Boone in the Disney film *Remember the Titans*. Racial tensions were stirred when Boone, an African American, was installed as the head coach of the T. C. Williams football team while Bill Yoast was assigned as assistant coach. The racial divide threatened the team's season, but Boone and Yoast worked together to bring home a state championship in 1971. Alexandria, Virginia, resident Gregory Allen Howard wrote the script for the popular film. (Courtesy Ron Baker.)

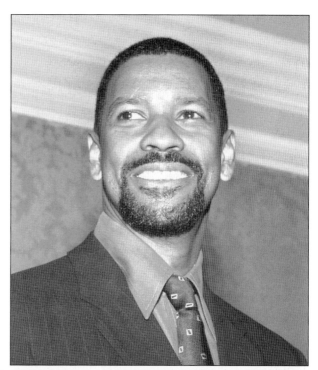

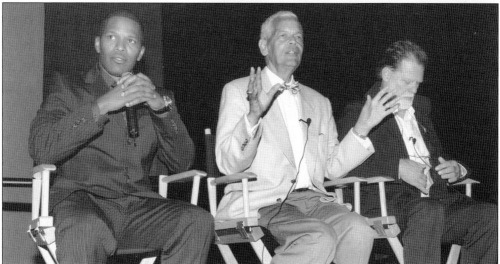

Actor Jamie Foxx (left), once known for his comedic talent, holds court with Julian Bond (center) and film director Taylor Hackford at a screening of the film *Ray* in 2004, which was sponsored by the Congressional Black Caucus in Washington, D.C. Foxx's stellar dramatic performance would earn him the Best Actor award for his portrayal of Ray Charles. Julian Bond has been in the public eye since he was first elected to the Georgia General Assembly in 1965. In 1974, he was elected to the Georgia Senate and left in 1987 after an unsuccessful bid to Congress in 1986. Director Taylor Hackford won an Academy Award for his short film *Teenage Father* in 1978. His films include *An Officer and a Gentleman*, *The Idolmaker*, *La Bamba*, *Hail! Hail! Rock 'n' Roll*, *The Devil's Advocate*, and *When We Were Kings*. (Courtesy Ron Baker.)

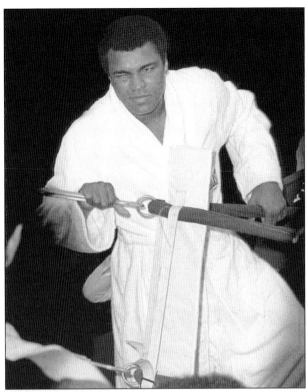

Muhammad Ali taunts the press after the official weigh-in at the Capital Center in Landover, Maryland. Ali fought and defeated challenger Jimmy Young on April 30, 1976. (Courtesy Ron Baker.)

Ali and Joe Frazier are the center of attention at the opening of the Ali Rotisserie in downtown Silver Spring, Maryland, in 1994. Joe Frazier was there to support his friend Ali as they welcomed customers, signed autographs, and kissed babies. (Courtesy Ron Baker.)

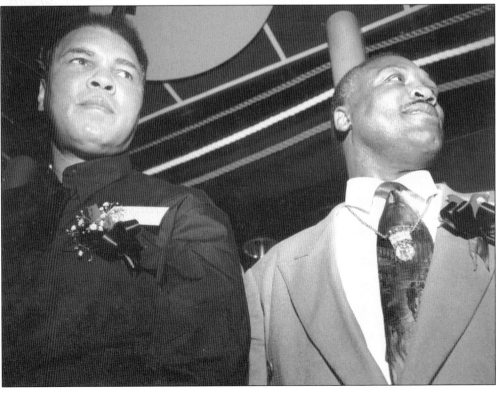

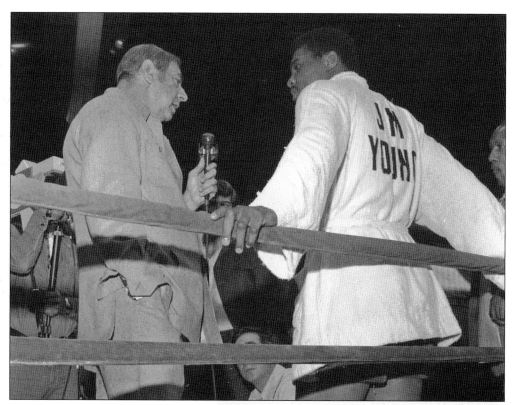

Legendary sports announcer Howard Cosell interviews heavyweight boxer Jimmy Young after his 1976 fight with Ali at the Capital Center in Landover. Young lost the fight in a decision. (Courtesy Ron Baker.)

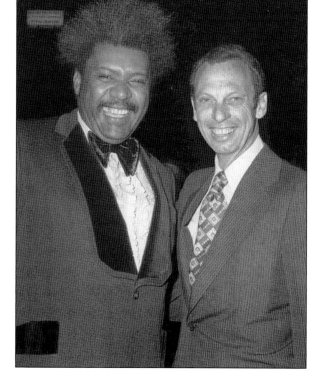

Fight promoter Don King poses with Abe Pollin, owner of the then Washington Bullets, the Capitals hockey team, and the Capital Center in Landover. King was attending the fight he promoted between Muhammad Ali and challenger Jimmy Young on May 1, 1976. (Courtesy Ron Baker.)

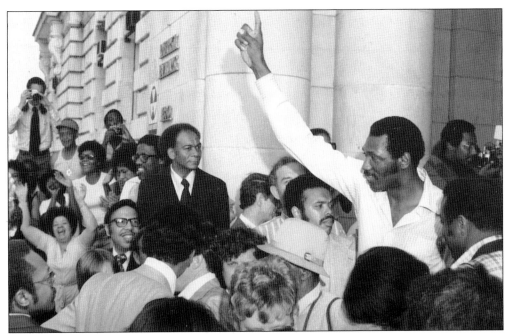

Washington Bullet Elvin Hayes waves to an throng of rabid fans from the steps of the Municipal Building in Washington, D.C., during a championship celebration for the Bullets, who won the NBA Championship in 1978. The team would go on to repeat as Eastern Conference Champions in 1979 but would fall to the Seattle Sonics in the finals. Hayes played for the Bullets, now know as the Wizards, from 1974 to 1981. (Courtesy Ron Baker.)

Tennis legend Arthur Ashe was the first African American selected to a Davis Cup team. Ashe won the U.S. Open in 1968, the Australian Open in 1970, the French Open doubles in 1971, and Wimbledon Singles in 1975. Ashe attends a Congressional Black Caucus Awards Dinner in 1977. (Courtesy Ron Baker.)

Venus Williams poses next to a bronze sculpture of her sister and herself at the Tennis Center in Southeast Washington, D.C., in 2002. Williams, who also learned to play tennis on an inner-city court, appeared at the facility to host a tennis clinic for children with an interest in the sport. The children learned tennis tips from Venus, who went pro in 1994 and has won more than 33 career singles titles and 10 career doubles titles. Serena and Venus Williams became the first pair of sisters to win a doubles title in the 20th century. (Courtesy Ron Baker.)

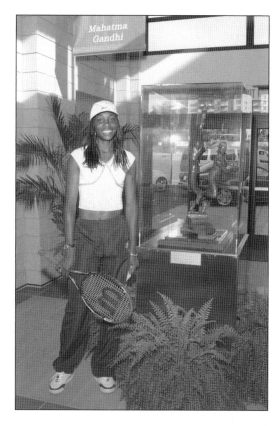

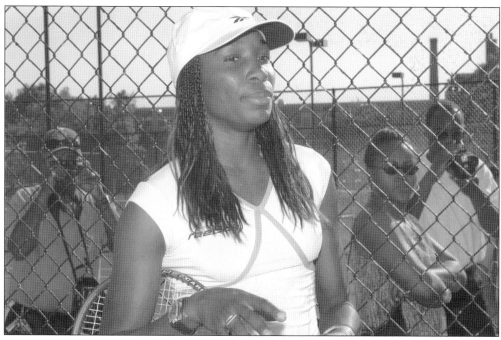

Venus stops to talk to the students. (Courtesy Ron Baker.)

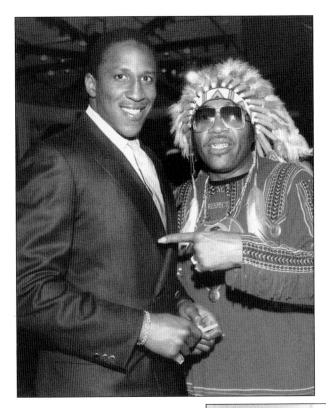

Rick "Dock" Walker (left) and Chief Zee shake hands at a post–Super Bowl party at the Foxtrappe Club to celebrate the Washington Redskins' 1982 victory over the Miami Dolphins, 27-17. Walker was the team's top tight end. Zema Williams was a devout Redskins fan better known as Chief Zee around Washington. (Courtesy Ron Baker.)

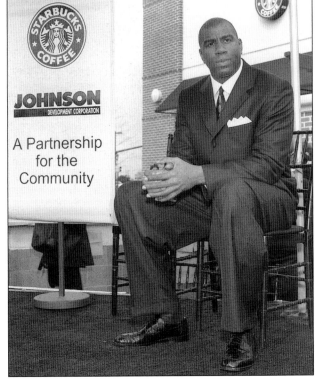

Earvin "Magic" Johnson waits to be announced during the dedication of his Starbucks store in Maryland in 2000. Johnson has expanded his entrepreneurial empire to include Magic Theaters and the Magic Johnson Foundation. (Courtesy Ron Baker.)

Four

WASHINGTON LIFE
Ordinary Folk

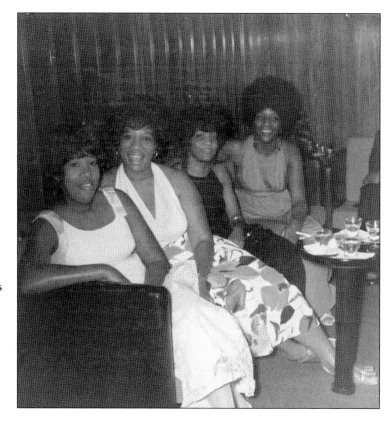

Here, from left to right, Washingtonians Dianne Bennett, Barbara Johnson, unidentified, and Audrey Williams relax on a cruise to the Bahamas *c.* 1970. (Courtesy Diane Bennett.)

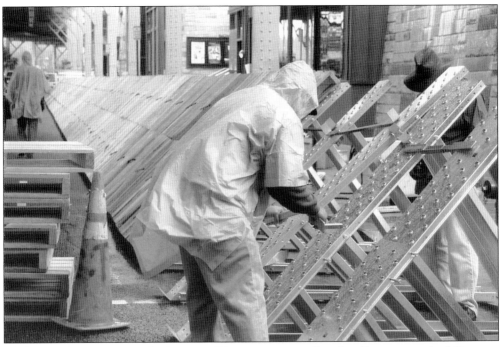

Workers on K Street near the Potomac River construct a flood wall to protect buildings on September 18, 2003. (Courtesy FEMA/photographer Liz Roll.)

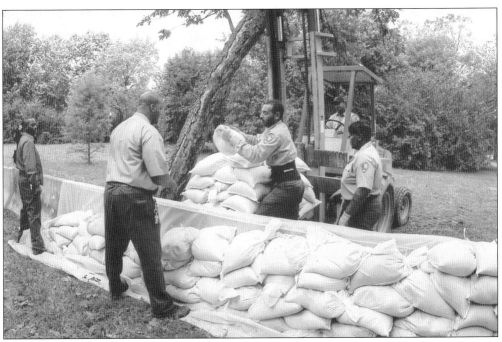

National Park Service employees sandbag across Seventeenth Street near the Tidal Basin in anticipation of flooding during high tide on the Potomac River on September 19, 2003. (Courtesy FEMA/photographer Liz Roll.)

Senior Renette Williams is a graduate of St. Cecelia's Academy. St. Cecelia's was an all-girl Catholic High School in Washington, D.C. (Courtesy Renette Williams.)

This is a graduation class photograph of Capitol Hill resident Pamela Johnson. Pamela graduated from Notre Dame Academy in Washington, D.C. (Courtesy Pamela Johnson Young.)

111

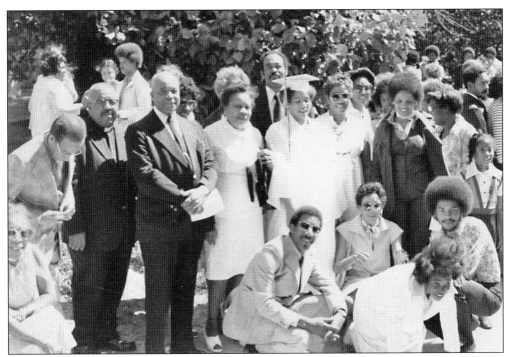

Shown here are the Watts, Johnson, and Williams families in 1976 attending Pamela Johnson's graduation ceremony from Notre Dame Academy. The ceremony was held at the National Shrine of the Immaculate Conception. (Courtesy Ron Williams.)

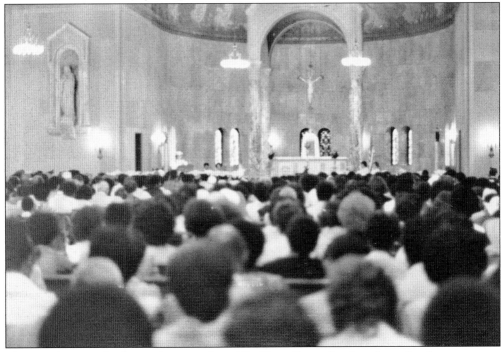

This is a photograph of an audience gathered for Notre Dame Academy's graduation ceremony inside the National Shrine of the Immaculate Conception. (Courtesy Ron Williams.)

Graduates and their families convene outside the shrine following commencement ceremonies. (Courtesy Ron Williams.)

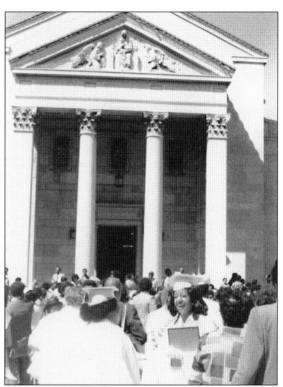

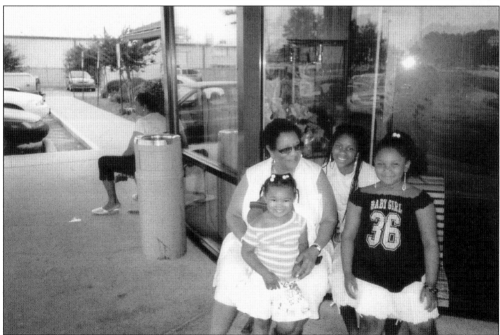

This photograph shows longtime Washingtonian Barbara Johnson, a nurse who retired from St. Elizabeth's Hospital, with three of her granddaughters. They are Raina (left) and Ryanna Goodine (right) and Jenae Dunham. Like many African Americans, Barbara migrated from North Carolina to Washington, D.C., with her mother, Mary Lee Watts. (Courtesy Phyllis Johnson.)

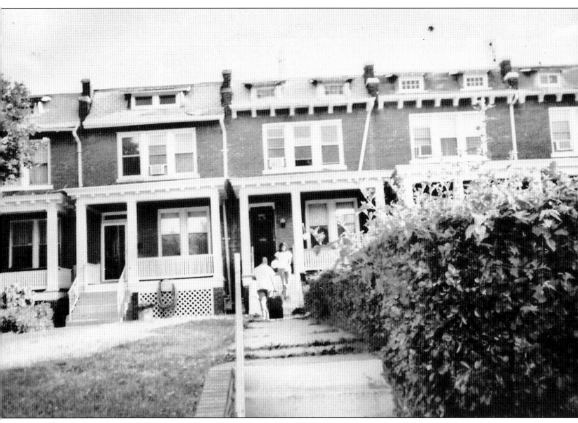

The Johnson family moved to this Capitol Hill house near the Congressional Cemetery in 1968. Bernard Caroll Johnson Jr., a native Washingtonian and retired deputy fire chief, was among a small group of African American schoolboys to integrate Archbishop Caroll High School, a private Catholic high school for young men. His wife, Barbara Johnson, a nurse, was a Southern transplant. They have three children. Johnson Jr., a retired firefighter, ascended through the ranks and became deputy chief of firefighting in the city. His father, Bernard Caroll Johnson Sr. was one of the first African American police detectives in Washington, D.C. Johnson Sr. was very active in the Catholic Church and was appointed to the position of deacon. (Courtesy Phyllis Johnson.)

This photograph shows Tracey Bennett at a park in Oxon Hill, Maryland, in the early 1970s. (Courtesy Tracey Gold Bennett.)

This photograph shows Mildred Williams of Greenville, North Carolina, and son Mitchell Williams of New York on an October 1969 visit to the home of Mildred's sister Mary Lee Watts on Capitol Hill. (Courtesy Tracey Gold Bennett.)

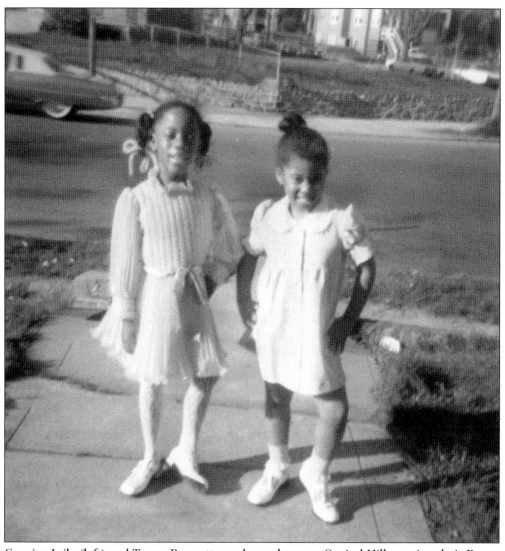

Cousins Laila (left) and Tracey Bennett are shown here on Capitol Hill wearing their Easter dresses in 1978. (Courtesy Tracey Gold Bennett.)

Five

UP FROM DOWN SOUTH

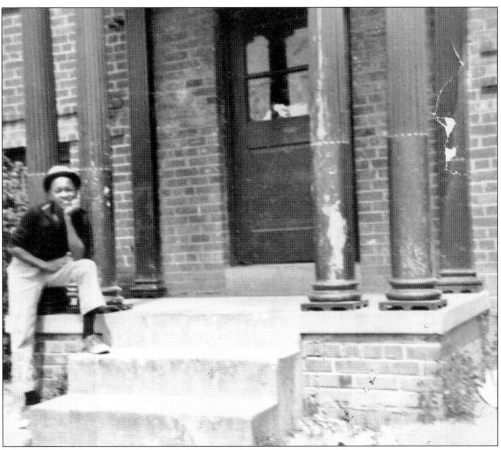

This photograph shows a young Ron Williams in Washington, D.C., during a summer visit from North Carolina in July 1965. Every year during summer vacation, Williams's mother, Mildred, would send him to her sister Mary's house in Washington, D.C. Ron, who grew up to be an artist and vice principal of a school in Research Triangle Park, traversed Washington, D.C., using the public transit system and worked various jobs to earn money for school and the car he drove as a teenager. (Courtesy of Ron Williams.)

Ron Williams and Anita Myers sit on the front porch of the Southeast Washington home of Ron's aunt Mary Watts, who lived on Burke Street, in August 1965. The Myerses were neighbors of Watts. (Courtesy of Ron Williams.)

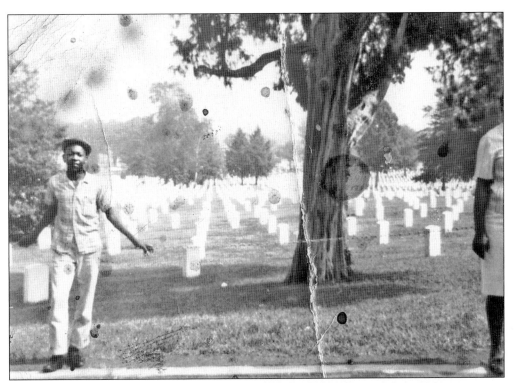

Here Ron Williams is pictured in August 1965 at Arlington National Cemetery, near Pres. John F. Kennedy's grave site. (Courtesy of Ron Williams.)

This photograph shows educator Ron Williams during an April 1997 return visit to the National Gallery of Art. This visit was one of numerous visits to Washington, D.C., sponsored by faculty for gifted and talented art students. (Courtesy of Ron Williams.)

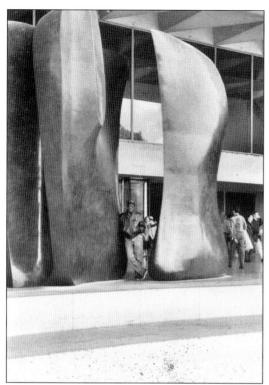

Ron Williams poses between two large free-form pieces of bronze sculpture near the entrance to the National Gallery of Art. (Courtesy of Ron Williams.)

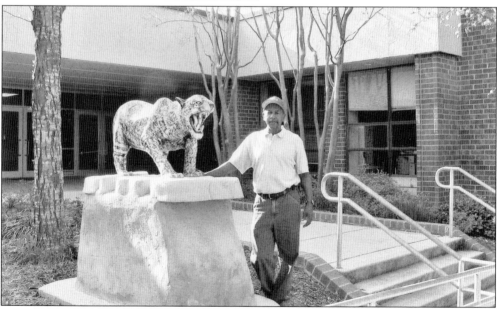

This photograph taken in May 2006 shows veteran educator and artist Ron Williams with one of his sculptures, a jaguar mascot sculpture commissioned by Athens Drive High School in Raleigh, North Carolina. Ron was the first African American to earn a master's degree in sculpture from East Carolina University in Greenville, North Carolina. Ironically, because of segregation, his older siblings could not attend East Carolina University. So to find opportunities, they migrated to Washington, D.C. (Courtesy of Ron Williams.)

Six

PLACES OF INTEREST

This photograph taken in the 1970s shows an unidentified girl sitting outside of Union Station. Annually, millions of travellers use the Amtrack hub and historic train station, which is also a tourist attraction filled with retail shops and restaurants. B. Smith's, an upscale restaurant located inside Union Station, is owned by Barbara Smith, a former model and television host of the network lifestyle show *B. Smith with Style* (which airs on TV One.) (Courtesy Library of Congress.)

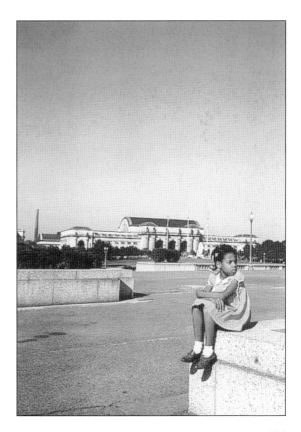

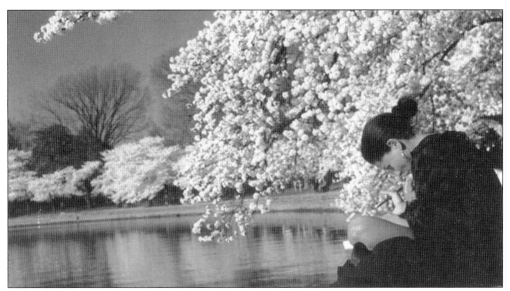

Thousands of people—citizens of Washington and tourists alike—make a pilgrimage of sorts to the Tidal Basin annually during late March and early April for the Cherry Blossom Festival. The blossoms usually hit peak bloom in late March. In this *c.* 2006 photograph, an unidentified artist captures the beauty of the blossoms. (Courtesy U.S. Department of Agriculture.)

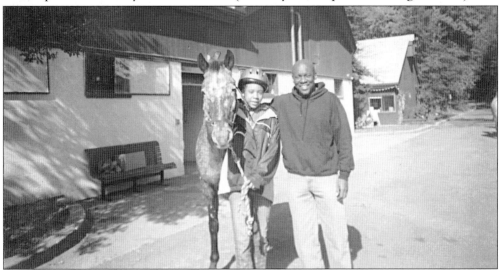

Jordi Hobbs's mother, Lisa, a classically trained vocalist and pianist, grew up in Washington and took horse riding lessons at these stables. Jordi Hobbs and her father, Dr. Reginald Hobbs, are shown here at the stables in Rock Creek Park with the horse Jordi is learning to ride. Dr. Hobbs is a computer scientist; he and his wife, Lisa, have seven children and live near Rock Creek in the tiny Northwest section of Washington, D.C. Lisa Chaplin Hobbs grew up a member of the "Talented Tenth." In 1903, W. E. B. Dubois wrote about what he identified as the "Talented Tenth." Dubois identified these individuals as an elite class of African Americans who would lead and "guide" the rest of the race toward social and economic opportunity. The daughter of a lawyer, Chaplin Hobbs lived around the corner from Carl Rowan, counted Piper Dellums (daughter of Roscoe and Congressman Ron Dellums) her friend, and babysat for Supreme Court justice Thurgood Marshall's children. (Courtesy Ron Baker.)

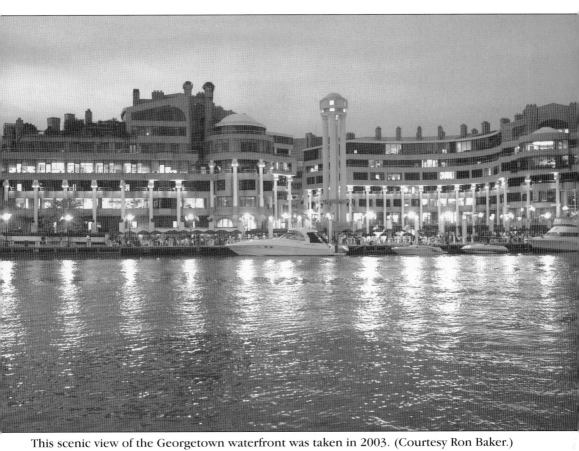

This scenic view of the Georgetown waterfront was taken in 2003. (Courtesy Ron Baker.)

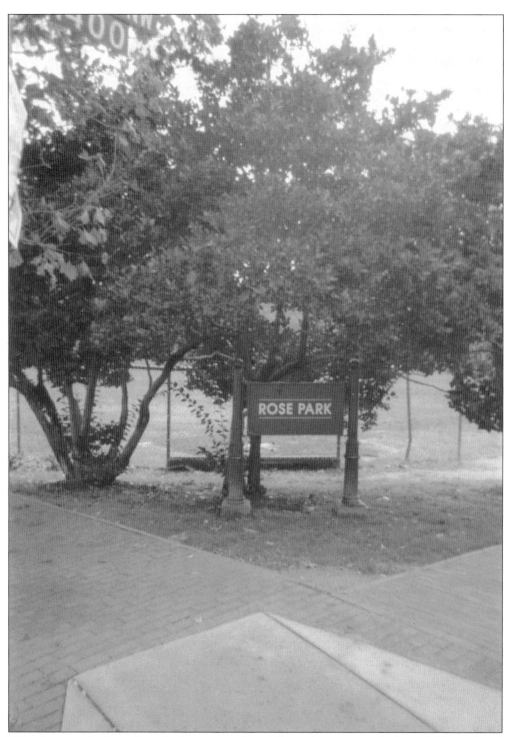

This photograph shows Rose Park, an area where African American and white children played until the 1930s, when a sign went up reading "For Coloreds Only." Citizens protested, and the sign was removed, ending the segregation. (Courtesy Yassir Abdalla.)

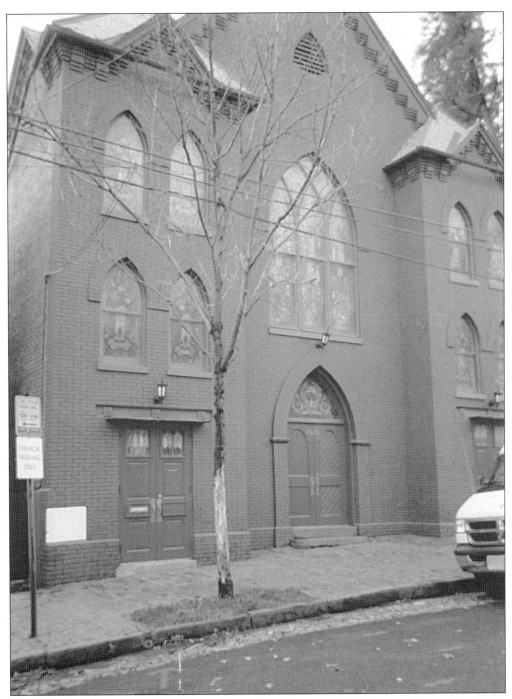

The First Baptist Church of Georgetown was founded in 1862. It is one of the oldest black Baptist churches in the Washington, D.C., area. A former slave, Rev. Sandy Alexander, is the original founder of First Baptist. Collins Williams had formally organized the congregation. Inside a private residence on Twenty-seventh and P Streets, Williams and his wife, Betsey, had led religious meetings in Georgetown. Williams donated a small parcel of land at Twenty-ninth and O Streets to be used for a church. (Courtesy Yassir Abdalla.)

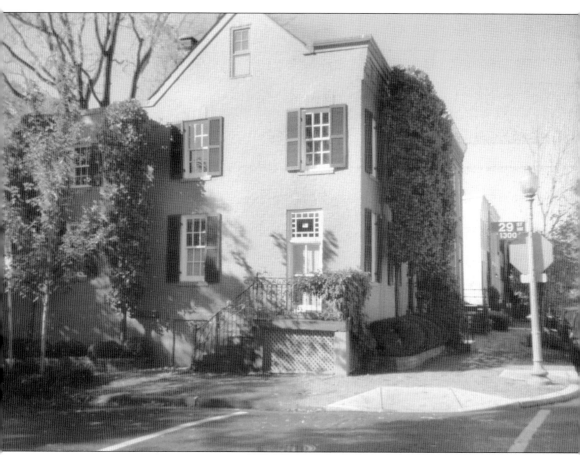

Georgetown was not always a part of Washington, D.C. In fact, in the 1700s, the former tobacco port belonged to Maryland. Now tourists and Washingtonians alike flock to the city's oldest neighborhood for its trendy shops and historic sites. Herring Hill in easternmost Georgetown was the area where African Americans lived following the Civil War. Herring Hill covers a 15-block section of Georgetown, south of P Street between Rock Creek Park and Thirty-first Street NW. The Black Georgetown tour, which happens every Saturday at the oldest house in the city, the Stone House, includes information about the slave trade in Washington. (Courtesy Yassir Abdalla.)

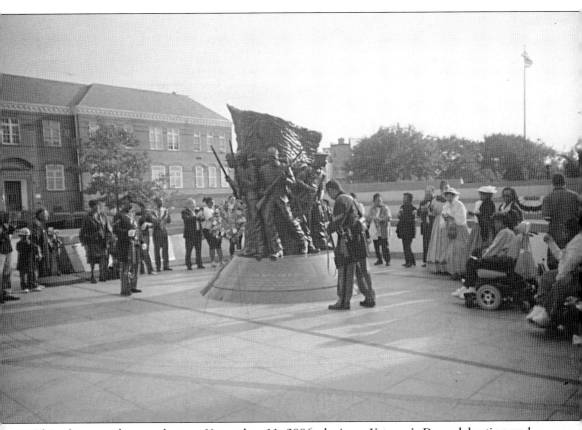

This photograph was taken on November 11, 2006, during a Veteran's Day celebration and wreath-laying held by the African American Civil War Museum. (Courtesy T. G. Bennett.)

ACROSS AMERICA, PEOPLE ARE DISCOVERING SOMETHING WONDERFUL. *THEIR HERITAGE.*

Arcadia Publishing is the leading local history publisher in the United States. With more than 3,000 titles in print and hundreds of new titles released every year, Arcadia has extensive specialized experience chronicling the history of communities and celebrating America's hidden stories, bringing to life the people, places, and events from the past. To discover the history of other communities across the nation, please visit:

www.arcadiapublishing.com

Customized search tools allow you to find regional history books about the town where you grew up, the cities where your friends and family live, the town where your parents met, or even that retirement spot you've been dreaming about.